IMAGES
of America

MADISON

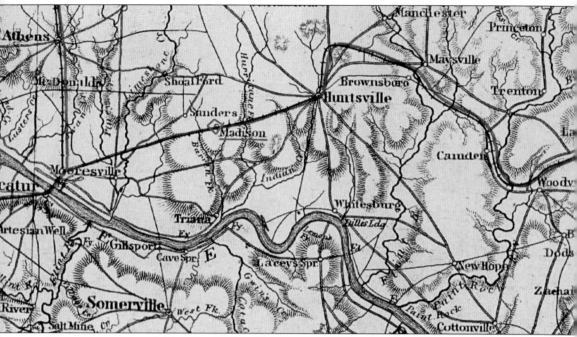

The map is excerpted from one produced by the Union army during its occupation of northern Alabama from 1862 through 1865 and into the Reconstruction era. It is the first known to use the name Madison for the town along the railroad about halfway between Huntsville and Decatur. Until official incorporation in 1869, the town was known as Madison Station. (Photograph from digital archives compiled by John Rankin.)

ON THE COVER: The store of Arthur Holding Lewis stood on the east side of the Main and Wise Streets intersection. Lewis, born 1848 in Triana, is in the doorway. He saw Madison initially planned and developed. Lewis, who shared ancestors with George Washington, died in 1914 after a long merchandizing career. (Photograph from digital archives compiled by John Rankin.)

IMAGES
of America

MADISON

John P. Rankin

ARCADIA
PUBLISHING

Published by Arcadia Publishing
Charleston, South Carolina

Printed in the United States of America

Library of Congress Control Number: 2013930803

For all general information, please contact Arcadia Publishing:
Telephone 843-853-2070
Fax 843-853-0044
E-mail sales@arcadiapublishing.com
For customer service and orders:
Toll-Free 1-888-313-2665

Visit us on the Internet at www.arcadiapublishing.com

This book is dedicated to pioneers of the area, who laid the foundations for their land to become the vigorous city that it is today.

CONTENTS

ACKNOWLEDGMENTS

The author first and foremost acknowledges that Jesus Christ as Lord and loving Savior has provided the inspiration, knowledge, desire, and time to accomplish this work. Appreciation is also due those who have done earlier related research and preserved records. Longtime, but now departed, Madison residents Percy Brooks Keel and Gladys McFarlen True collected historical data about Madison for years. They passed much of their information to the author as an understudy during the 1990s. Percy even coordinated and participated in personal interviews with other "oldest living memories" of the town. Additionally, the Madison Station Historical Preservation Society's authors committee of the 2003 issue of the *Madison Walking Tour Book* is highly appreciated.

The staff of the Huntsville–Madison County Public Library's Heritage Room (Raneé Pruitt, Susanna Leberman, Ann White Fuller, Richard White, and others) plus the staff of the Madison County Records Center of the Probate Court (Rhonda Larkin, Donna Dunham, Kayla Rike, and now Donna Barlow) have provided assistance and access to historical data and archived photographs. Even archived tax records, preserved by Diann Long of the tax assessor's office in the main library building, have been consulted. Resources such as Ancestry.com have provided census and other records needed for pertinent research.

Patient family support—especially from the author's wife, Mildred—was absolutely essential through the years spent collecting the material for this work. The author, working with other historians, has digitally produced, restored, or archived the photographs utilized in this book, except where attributed to other sources. Lastly, those who were willing to share information and allow photographic copying are thanked for providing insight into the lives of their ancestors.

INTRODUCTION

To understand the background context of Madison's founding, it should be noted that in 1803, at the time of Pres. Thomas Jefferson's purchase of lands west of the Mississippi River from France, the land of northern Alabama was still known as Indian Territory. The area was somewhat claimed by several states to the east, but only a few trappers, hunters, and land speculators had explored the region. However, the earliest settlers did begin squatting (living and farming without ownership) on the Indian lands before 1800. By 1805, the Cherokee Nation had ceded the land of eastern and central Madison County to the federal government, but the location that became the town of Madison remained under Chickasaw and Creek Indian possession until after the War of 1812. The Creeks' claim was surrendered upon their defeat at the Battle of Talladega. Because of the extent of white settler pollution of their hunting grounds, the Chickasaws ceded land as far west as the Elk River in 1816.

Cotton was the reason for the land rush by the settlers. Land in the area could be bought for as little as $1 per acre. Of course, the best land was sold for as much as $4 to $7 per acre. However, the average yield per acre per year of cotton farmed on the land would sell for as much as $400. This was at a time when the eastern farms established during the colonial days were producing poor crops due to their depleted soil, with lack of any commercial fertilizers to restore fertility. Cotton farming and shipping rapidly developed over northern Alabama, prospering new river towns such as Triana, which was established in 1818 just seven miles south of where Madison would be founded 39 years later.

By 1818, the US government completed a systematic survey of the ceded Indian lands into grids of townships (north-south, six-mile groups) and ranges (east-west, six-mile groups), with each grid consisting of 36 sections. Each complete section consisted of 640 acres arranged in a square, with the squares measuring a mile on every side. The 16th sections in the middle of every township and range coordinate set were reserved by the government for the state's use to fund public education. This was generally accomplished by leasing the land to farmers, preserving it for unspecified public uses, or selling cut timber. However, states did have the option of selling the 16th sections for cash to promote public education. Alabama was the first state in the nation to have such systematic surveying before authorized sale of the land.

With respect to cotton shipping, James Clemens of Huntsville in 1854 foresaw the importance of the Memphis and Charleston Railroad that was being constructed. Jeremiah Clemens, son of James, was a US senator, probably with insider information about the planned route of the railroad. With that knowledge, and aware that the 1850s locomotives needed to take on water for steam and wood for fuel about every 15 to 20 miles, Clemens purchased the 16th section that lay 10 miles west of Huntsville and 15 miles east of Decatur. In 1857, Clemens sketched the plan for a new town at Madison's location, in the 16th section of Township 4 South, Range 2 West. His intention was to establish a town around a railroad station to be called Clemens Depot as his legacy namesake. However, for unknown reasons, the railroad maps labeled the location as

Madison Station. The name was changed to be only Madison at the time of incorporation by the state legislature in 1869.

The paternal great-grandfather of James Clemens was also a great-great-grandfather of Samuel Langhorne Clemens, better known as the famous American steamboat pilot, humorist, and author Mark Twain of the 1800s. James Clemens, born 1778 in Pennsylvania, came to Huntsville from Kentucky around 1812. Both James and his son Jeremiah freed some of their household slaves significantly before the Civil War. A former slave of James Clemens remained as a free person in his household with the surname of Clemens in the 1860 census, when James was listed as age 83. James Clemens died on June 7, just days after that census was taken. Three months prior to his death, James sold the last lot in Madison that he personally transacted to a free black man named Edmund "Ned" Martin. Martin bought the preeminent residential location at the junction of two primary streets in town, today's Front and Sullivan Streets. Madison has always accepted and celebrated a multicultural population, including former Union soldiers who moved south to the land that they had occupied during the Civil War.

Throughout its years from the time of being reserved to the state as school lands, Madison has been noted for quality education. As both an underlying reason and a result, Madison has always been home to some widely influential people. Situated today very near several universities, the Army's Redstone Arsenal, NASA's Marshall Space Flight Center, and one of the largest engineering research centers in the world, Madison continues to maintain and expand upon its educational level. It is now the fifth-largest city in the state, lying adjacent to Huntsville. Madison's own population of about 45,000 lives mostly in Madison County, with some citizens residing in adjacent parts of Limestone County. The city's public school system is made up of 2 high schools, 2 middle schools, and 11 elementary schools. Madison's latest and most modern high school is named for the town founder, James Clemens. Until the new high school was completed in 2012, the other—Bob Jones High School—was the largest in the state. It consistently ranks in the highest levels of educational achievement in the nation. Madison is a city of mostly single-family private residences in planned developments with lots of green space, parks, walking trails, and sports provisions. Its per capita income is among the very highest in the state, while cost of real estate and living in general is rated among the lowest in the country. Madison is characteristically rated as one of the best places to live and work in America.

Keep in mind that the words and photographs herein represent a snapshot in time of the continually evolving knowledge of the history of Madison. Emphasis is upon the way it was, more so than the way it is now. More detail about family histories and old pictures of the town can be found in Madison's sesquicentennial book, *Memories of Madison: A Connected Community, 1857–2007*, published in 2007 by the Donning Company Publishers and written by John Patrick Rankin.

One

IN THE BEGINNING

Before Madison was founded in 1857, the area around its location in the 16th section was relatively well populated from the early 1800s because of the fertility of the soil and the mostly flat land, ideal for raising cotton. Nearness to Triana, the local cotton shipping port, strongly attracted planters to the vicinity. Among pre-Madison landowners in the area were Thomas Bibb, William Lanford, James Manning, Elijah Boardman, Clement Comer Clay, James Wiggins, Michael Farley, Daniel Whitworth, James Bailey, Charles Betts, James Collier, Burwell Clinton Lanier, William Gray, John Cartwright, Meriwether Anderson Lewis, Richard Lipscomb, Steptoe Pickett, Richard Holding, Francis Ephraim Martin, Elisha Rainbolt, Roland Gooch, and William Slaughter. These men, or some of their descendants and close relatives, were notable citizens of Madison while it was called Madison Station from1857 to 1869.

There were two men named Thomas Bibb that were instrumental in history of town. The earlier one was the 1819 president of the Alabama Senate and brother of the first governor of the state. He became the second governor when his brother William died unexpectedly while in office. Thomas Bibb and Waddy Tate were among 197 men who signed an 1816 petition requesting permission to remain as squatters on Indian lands known as the Sims Settlement, which included Limestone County as well as western Madison County. The petition was delivered to the US Congress in early 1817. It worked. They became legal purchasers of the land in 1818. The later Thomas Bibb was a distant cousin of the governors. He owned land, now developed, in the center of the current city limits. Elijah Boardman had land that is part of Redstone Arsenal today. He imported thoroughbred horses from Europe in the 1820s and 1830s. Boardman established his ranch along Indian Creek and raced in eastern states and Europe. His brother John was a newspaper publisher and was selected to print Alabama's first constitution. These men, their descendants, and relatives had significant accomplishments in northern Alabama, and some did so in other regions, states, and countries.

Andrew Jackson, later hero of the Battle of New Orleans and US president, reportedly was ordered to clear the squatters from the Indian lands of Madison and Limestone Counties, but he refused. He was replaced, and another commander of federal troops burned the squatters' houses and crops a few times until 1815.

Thomas Bibb, along with Dr. Waddy Tate and Gen. William Adair, was a trustee of the 1818 pre-Madison town of Triana, a major shipping port for the produce from cotton blooms, one of which is shown here. Triana was established at the junction of Indian Creek with the Tennessee River. It is the only town in America named for the first sailor to sight land from a ship on the first voyage of Columbus to America.

Thomas Bibb (1782–1839) served as Alabama's governor in 1820 and 1821. His Bibb lineage connects with colonial Pope, Wyatt, and Dandridge families. Bibb's maternal grandmother, Dorothy Dandridge, was an aunt of Martha Dandridge, who was married first to John Parke Custis and then to George Washington, first president of the United States.

Belle Manor was the name given by Thomas Bibb, second governor of Alabama, to the house that he built in Limestone County in 1826. The village of Belle Mina, a neighbor of Madison, grew around it. In 1870, Bibb's grandsons Thomas and John Hopkins lived in Madison with their mother, Eliza, the governor's eighth child.

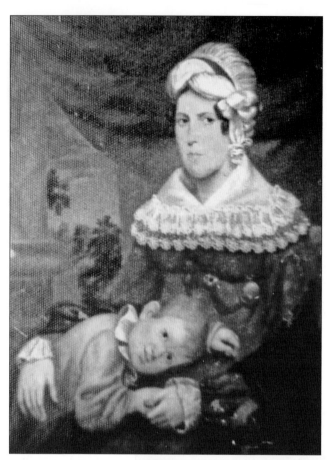

Pamelia, daughter of wealthy planter Robert Thompson, married Thomas Bibb in 1805, while both were living in Petersburg, Georgia. The Bibb, Thompson, and Pope families had all come from Virginia to Petersburg and moved together to Madison County by 1809. The portrait shows Pamelia with Robert Thompson Bibb, one of her 11 children (three died in infancy).

One side of the historical marker across the country lane from Belle Manor provides a summary of the Bibb family prominence in the area. The Bibb children all married well. For instance, daughter Adeline married James Bradley. Their child, Susan Bradley, married Thomas Wilson White, a mayor of Huntsville and namesake of Whitesburg, the location of one of his plantations.

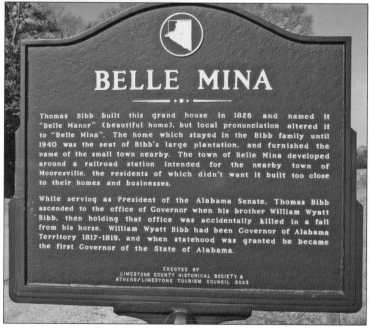

BELLE MINA

Thomas Bibb built this grand house in 1826 and named it "Belle Manor" (beautiful home), but local pronunciation altered it to "Belle Mina". The home which stayed in the Bibb family until 1940 was the seat of Bibb's large plantation, and furnished the name of the small town nearby. The town of Belle Mina developed around a railroad station intended for the nearby town of Mooresville, the residents of which didn't want it built too close to their homes and businesses.

While serving as President of the Alabama Senate, Thomas Bibb ascended to the office of Governor when his brother William Wyatt Bibb, then holding that office was accidentally killed in a fall from his horse. William Wyatt Bibb had been Governor of Alabama Territory 1817-1819, and when statehood was granted he became the first Governor of the State of Alabama.

ERECTED BY
LIMESTONE COUNTY HISTORICAL SOCIETY &
ATHENS/LIMESTONE TOURISM COUNCIL 2003

The other side of the Belle Mina historical marker relates that Porter Bibb, son of the governor, built a plantation house called Woodside within sight of Belle Manor as a wedding gift for his daughter Mary. Plantation families of the area intermarried extensively, linking the Bibbs with Garrett, Peete, Pickett, Bailey, and other families of the immediate vicinity.

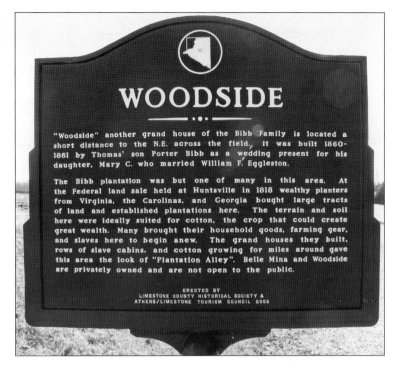

WOODSIDE

"Woodside" another grand house of the Bibb Family is located a short distance to the N.E. across the field. It was built 1860-1861 by Thomas' son Porter Bibb as a wedding present for his daughter, Mary C. who married William F. Eggleston.

The Bibb plantation was but one of many in this area. At the Federal land sale held at Huntsville in 1818 wealthy planters from Virginia, the Carolinas, and Georgia bought large tracts of land and established plantations here. The terrain and soil here were ideally suited for cotton, the crop that could create great wealth. Many brought their household goods, farming gear, and slaves here to begin anew. The grand houses they built, rows of slave cabins, and cotton growing for miles around gave this area the look of "Plantation Alley". Belle Mina and Woodside are privately owned and are not open to the public.

ERECTED BY
LIMESTONE COUNTY HISTORICAL SOCIETY &
ATHENS/LIMESTONE TOURISM COUNCIL 2000

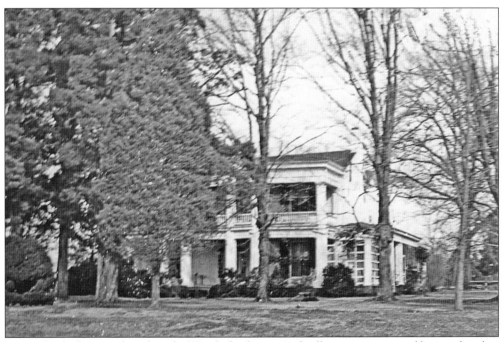

Except for the historical marker, the Woodside plantation dwelling goes unnoticed by travelers, but it still stands proudly, a few hundred yards from the main road. The property passed into ownership to the Witt, White, and Pepper families, giving this grand house ancestral ties to the Spottswood, Matthews, Minor, and Washington families that shaped American colonial history.

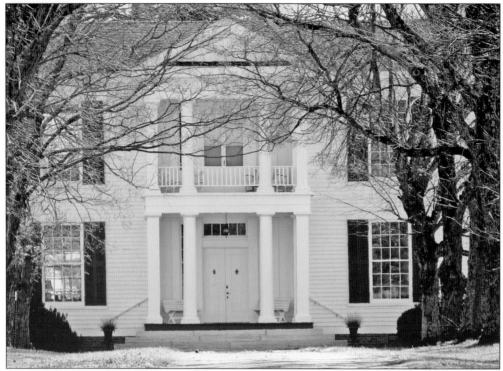

The Maclin-Horton-Garrett house was built in Athens by Dr. Benjamin Maclin in 1848. In 1934, it was dismantled and moved to the south side of Old Highway 20. The house history includes visits by Pres. James A. Garfield and judge James E. Horton, who presided at the trial of the Scottsboro Boys in 1933. Even Gen. Nathan Bedford Forrest dined in the house.

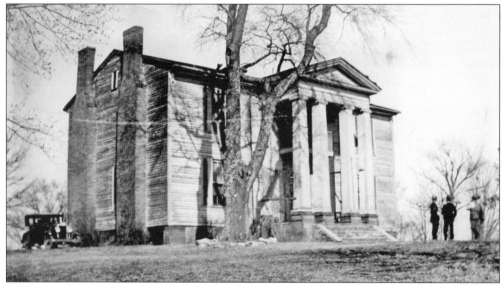

Constructed in 1853 and 1854 on 2,000 acres bought by William Lanford, the Lanford-Slaughter house is on the east bank of Indian Creek and north side of Old Madison Pike. Lanford married Charlotte, a daughter of Isham Fennell and Temperance Jordan. Lanford's daughter Mary wed Madison physician John Slaughter, the namesake of Slaughter Road.

Isham J. Fennell is commemorated with the largest monument among many in Huntsville's Maple Hill Cemetery. His wife, Temperance, was a daughter of Bartholomew Jordan, a Revolutionary War patriot and namesake of Jordan's Chapel (established in 1820) and Jordan Lane in Huntsville. The Jordans lived very near where the US Space & Rocket Center is located today.

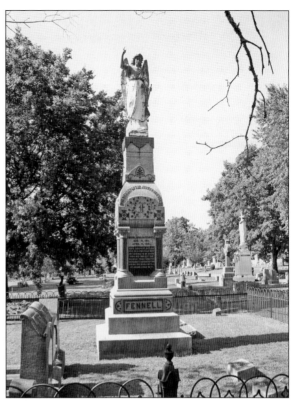

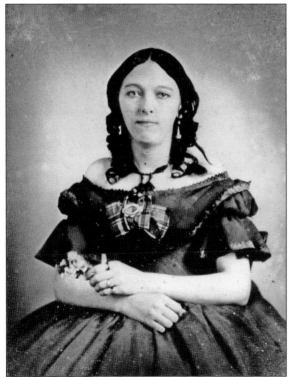

Amanda Carnes married into the Camper family that came into possession of the Lanford-Slaughter house in 1919 when Olin Camper purchased the property. Amanda was the wife of Blooming Goodner Camper, a brother of Robert Isaac Camper, Olin's father. Robert lived on the east bank of Indian Creek where the Catholic High School is now, very close to the Lanford-Slaughter-Camper house.

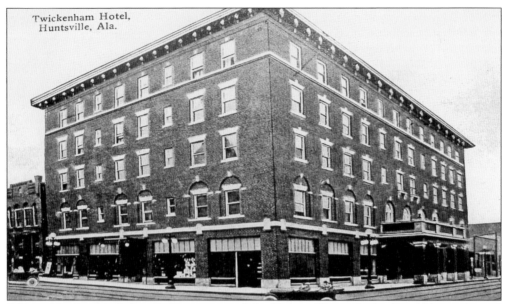

Twickenham Hotel,
Huntsville, Ala.

Olin and his brother Robert E. Camper owned the Toggery Shop, which offered "fine tailoring" and "exclusive gent's furnishings," in Huntsville. Robert E. Camper was, for a time, the owner and operator of Hotel Twickenham, said to be the "Pride of Huntsville" in the 1930s. There was even a Camper Brothers Garage operating in the area in 1915.

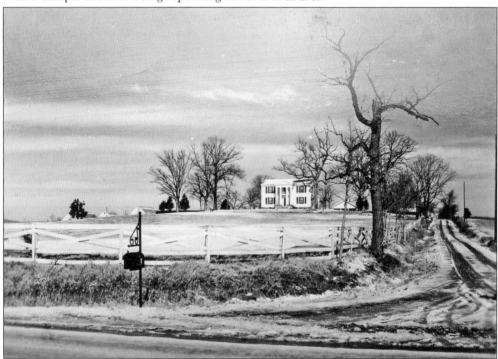

A view of the Lanford-Slaughter-Camper house, from the southern approach along the old Highway 20 route of the creek crossing, shows the three barn roofs to the west of the house. This photograph is believed to have been made in the 1950s before the west wing of the house was added. The estate includes three houses today.

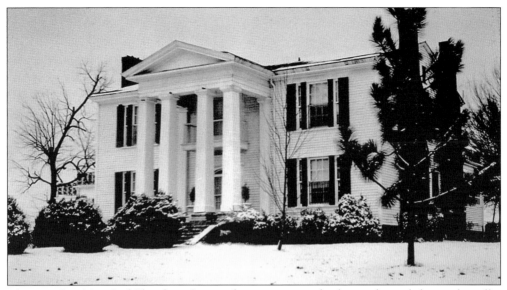

The completed Lanford-Slaughter-Camper house as it is today but with much less and smaller shrubbery is shown in this photograph, which includes a glimpse of the west wing. The image, captured from a southeastern perspective after a snowfall, is believed to have been taken in the 1960s and definitely before 1971.

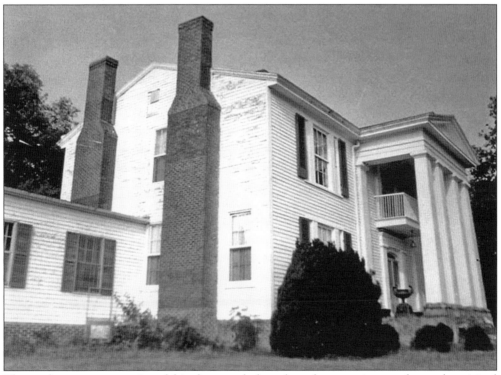

The southwestern perspective of this photograph shows how the west wing attaches to the original structure of the Lanford-Slaughter-Camper house. The steps of the added wing at its southwestern corner are constructed of slave-made bricks, apparently older than even the main house structure. The property has been owned by Dr. Oscar Simpson since 1971.

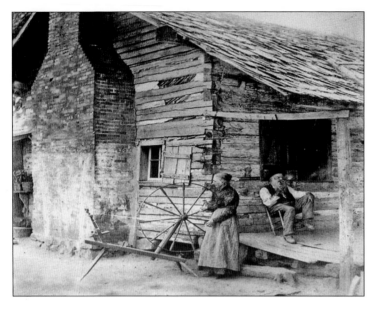

Not all pioneers of the area had stately homes, of course. Most early farmers, especially those who had no slaves prior to the Civil War, constructed smaller dwellings, like this photograph shows. Some of the local families believe this to show Robert Donnell Tribble and his wife, Martha Gooch, but others say it is Nathaniel Matson Gooch and his wife, Susan Caroline Litzy. Either match is possible.

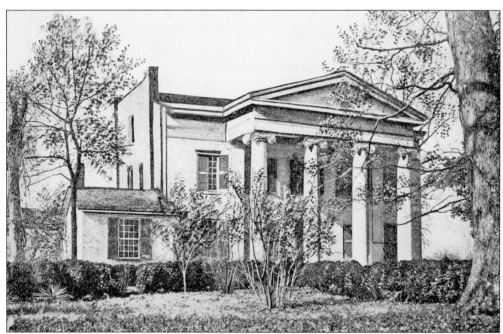

One of Huntsville's grandest old mansions that are now gone with the wind was built in 1815 by James Manning, who had a plantation south of the Lanford house, around where Gate 9 of Redstone Arsenal is today. His property was later bought by Luke Matthews, namesake of Matthews Cave. Manning's daughter Sarah Sophia married Gen. Bartley Lowe.

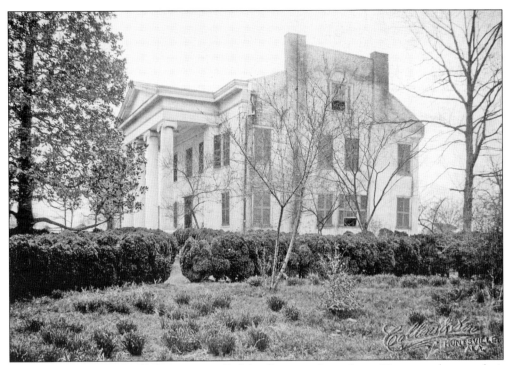

James Manning's Huntsville house was called the Grove, and stood on a 33-acre yard near today's intersection of Gallatin Street with Lowe Avenue, which was named after Manning's son-in-law, who lived there after James died. Lowe's daughter Sophia married Nicholas Davis Jr., whose father was a candidate for governor of the state.

The back parlor of the Manning-Lowe house reflects the prominence of the family. James Manning's wife, Sophia Thompson, had sisters who married well also. Eliza Thompson married Waddy Tate. Pamelia Thompson married Thomas Bibb, second governor of the state and owner of Belle Manor as well as another large Huntsville house.

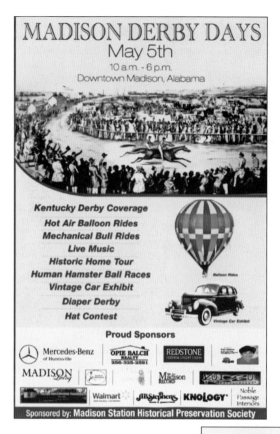

Horse racing was big business in the plantation era, especially with respect to the 1818–1830s Boardman Mills thoroughbred stables of Elijah and John Boardman. Those thoroughbred stables were southeast of where Madison was later founded and southwest of the Redstone Arsenal Airfield. An annual celebration in Madison now coincides with the running of the Kentucky Derby.

A Derby Day brochure developed by Charles Nola of Madison includes an old Huntsville newspaper ad for a race at Green Bottom Inn, highlighting Telemachus. The brochure also has an illustration of Glencoe of Florence, Alabama, who sired 14 Kentucky Derby winners, including Peytonia. In 1845, Peytonia won the North-South race in New York City.

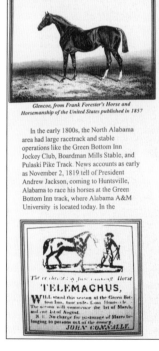

Glencoe, from Frank Forester's Horse and Horsemanship of the United States published in 1857

In the early 1800s, the North Alabama area had large racetrack and stable operations like the Green Bottom Inn Jockey Club, Boardman Mills Stable, and Pulaski Pike Track. News accounts as early as November 2, 1819 tell of President Andrew Jackson, coming to Huntsville, Alabama to race his horses at the Green Bottom Inn track, where Alabama A&M University is located today. In the

The celebrated just running Horse
TELEMACHUS,
WILL stand this season at the Green Bottom Inn, four mile from Huntsville. The season will commence the 1st of March, and end last of August.
N. B. No charge for pasturage of Mares belonging to persons out of the county.
JOHN CONNALLY.

early morning hours of November 13, 1833, attendees at the Pulaski Pike Track races witnessed the spectacular Leonid meteor shower that is known to have inspired the famous 1934 jazz standard "Stars Fell on Alabama."

Not many are aware that just a few miles from downtown Madison, Alabama, the vision of brothers Elijah and John Boardman significantly influenced horse racing in the United States through the breeding of American Thoroughbreds in the early 1800s. Horses bred in the stables of Boardman Mills seeded the area with the lines from royal studs at England's Hampton Court, Lord Chesterfield's, the Duke of Grafton's and Sir Thomas Stanley's.

In 1838, the Boardman brothers stocked Boardman Mills with imported stallions, brood mares, and choice horses personally selected by a noted English horseman named Richard Tattersall. "It is the only establishment of its kind in the United States," wrote the Editor of The Spirit of the Times, "and it is conducted upon a scale so grand, both in regard to the extent and the quality and value of its stock, as to rival the most celebrated studs in England." These initial imported stock helped transition American breeding in the United States with lineage that continues today.

The Boardman brothers' business savvy to capitalize on saving American breeders the time and money necessary to go to England for stock was assisted by North Alabama's racing prominence and trends

The James Wiggins plantation around the Wall-Triana Highway intersection with James Record Road reached almost to Boardman Mills. Richard, the son of James, married Jackey Dunn, sister of Madison's first railroad depot agent, physician William Barham Dunn. In this photograph, Mark Hubbs is shown examining the Wiggins family cemetery central obelisk.

Madison judge Robert Emmett Wiggins (1843–1929) wrote in his 1916 input to an official history of Alabama that Jeremiah Clemens and Clement Claiborne Clay were both born on their respective fathers' plantations within two miles of Madison's historic founding site. Robert, grandson of James Wiggins, was age 14 when the town was founded.

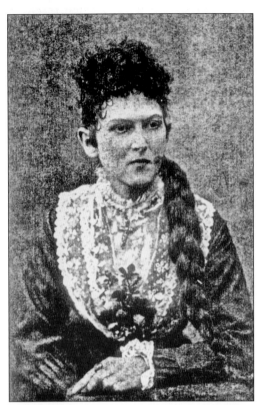

Lutie Fletcher Wiggins (1856–1918) was a daughter of Edward Augustus Fletcher. The family settled early in the Shoal Ford area of Limestone County, near the family of James Nicholas Fletcher, whose son Richard Matthew Fletcher became one of Madison's Civil War–era physicians. Lutie married Robert Emmett Wiggins in 1884.

James Clemens, the founder of Madison, never resided in Madison, but his son Jeremiah was born on the Clemens plantation just south of the town. The Huntsville Clemens residence, now moved to accommodate Huntsville Utilities offices and parking, was located at Clinton Avenue and Gallatin Street near the Big Spring. Clemens had several plantations, each with a big house.

Noted author, humorist, and riverboat pilot Samuel Langhorne Clemens, more commonly known as Mark Twain, was a distant cousin of James Clemens. They shared ancestry through Ezekiel Clemens, who migrated from Massachusetts to Pennsylvania in 1701 and died in 1798. Their Clemens ancestry has been traced back to Robert Clements (1595–1658) in England.

The 1858 and 1859 Huntsville City Directory lists James Clemens in his Clinton Avenue house. Jeremiah lived on Eustis Street, while his wife, Mary, is listed in her father's household. In the 1860 census, both Jeremiah and Mary were with her father, John Read. The directory also has data for John Withers Clay, another Madison connection.

HUNTSVILLE CITY DIRECTORY, 1858 - 1859

46 HUNTSVILLE ADVERTISEMENTS.

P. W. SPOTSWOOD,
WHOLESALE AND RETAIL
DRUGGIST AND APOTHECARY,
AND DEALER IN
Paints, Oil, Window Glass, Varnishes, Dye-Stuffs, &c.
Physicians' Prescriptions carefully compounded.
No. 16 COMMERCIAL ROW, HUNTSVILLE, ALA.

LARCOMBE'S

PHOTOGRAPHIC & AMBROTYPE GALLERY,
Franklin Hall, Franklin St, near Public Square,
HUNTSVILLE, ALABAMA.

COO 47

CLAY J. WITHERS,
 Editor and Proprietor of Democrat, office e s Jefferson b Randolph and Clinton, opp Huntsville Hotel, res s e c Henry and Gates
Claybrooks Wm. machinist, bds Wm. Brannan's
Clem Thomas, bk mason, w s Church b Holmes and Arms'
Clemens James, planter, res s s Clinton e of Gallatin
Clemens Jeremiah, att'y, res s s Eustis b Green and Lincoln
Clemens Mrs. Mary L. at John Read's
Clopton J. A. phys, n s Public Square (Donegan's Block)
Coleman Miss Amanda, n e c Green and Randolph
COLEMAN JOHN J.
 Attorney at Law, Notary, Commissioner of Deeds, Examiner in Chancery, and Master in Chancery, U. S. District Court, office Court-house, h n e c Madison and Williams
Coleman Miss Narcissa, n e c Green and Randolph
Coles Mrs. Eliza F. w s Franklin b Williams and Dry Creek
Coles Mrs. James, at Samuel Cruse's
Coles Robt. T. student, w s Franklin b Williams and Dry Creek
Colgan Anthony, harness mkr, bds Britain Frank's
Colhoun Meredith, planter, n e c Eustis and Green
Collier Thomas H. clk, s s Eustis b Green and Lincoln
Collins ——, brakesman, bds Mrs. L. Thomason's
Collins A. carp, bds Joseph M. Jett's
Collins John, carp, bds Wm. S. Kerr's
COLTART JOHN G.
 (C. & Son), bds Samuel Coltart's
COLTART ROBT. W.
 n e c Clinton and Gallatin
COLTART SAMUEL.
 General Insurance Agent. Office, 10 Commercial Row, s s Public Square b Franklin and Madison, res e end of Franklin
COLTART & SON.
 (Samuel & John G.) Dealers in Clothing, Books, Stationery, Fancy Articles, &c. 10 Commercial Row, s s Public Square b Franklin and Madison
Colton, Wm. L. engineer, n s Meridianville Road opp Green
Combs Mrs. Martha, bds Wm. S. Kerr's
Combs Miss Sarah, bds Wm. S. Kerr's
Connell John O. carp, bds w s Washington b Holmes and RR
Conway James, marble cutter, bds A. A. Baker's
COOK DAVID.
 Carriage Depository, e s Franklin b Eustis and Gates, bds W. D. Chadick's
Cook Geo. W. att'y, n w c Holmes and Jefferson
Cook Peter M. harness mkr, bds B. Frank's
Cook Sidney, steward Venables Hotel

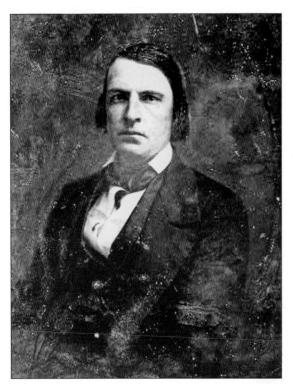

Jeremiah Clemens never legally inherited the property of James because the estate was tied up in litigation until after 1868. James died in 1860 at age 84, and Jeremiah died in 1865. As a US senator, Jeremiah became relatively unpopular for his antislavery positions, which he shared with his father. Both freed household slaves before the Civil War.

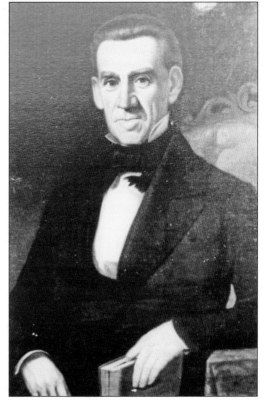

Clement Comer Clay came to the area in 1811 and soon acquired multiple plantations, including one at the north end of the site of today's airport. That plantation adjoined the land of John Withers. Clay married John's daughter Susanna Claiborne Withers in 1815. Their first child, Clement Claiborne Clay, was born on this plantation just outside Madison, close to Susanna's mother.

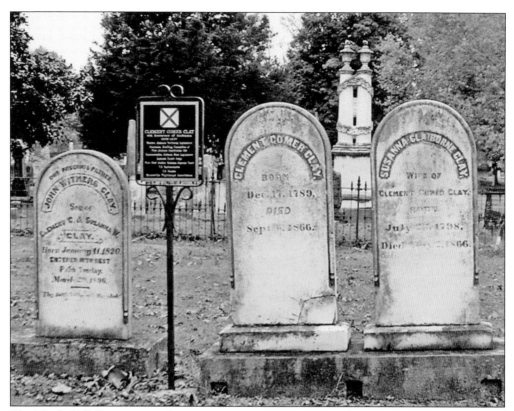

The Maple Hill Cemetery markers in Huntsville show that John Withers Clay, second son of Clement and Susanna, is buried beside his mother and father. John Withers Clay was initially an attorney, later publishing the *Huntsville Democrat* newspaper for about 40 years. He married Mary Lewis and had at least nine children.

Clement Comer Clay began his career as a lawyer. He served many years in the highest offices of the state, including a term as the eighth governor in 1836 and 1837. He was also as a state and federal representative and senator, as well as state supreme court chief justice. In his 70s, he was imprisoned by Union troops and died in 1866.

This picture is included in the Clay family photographic archives, but it has no notations. It is believed to likely be an image of Susanna Claiborne Withers Clay, considering its apparent age and women's clothing styles of the period of Susanna's life. Other photographs in the collection depict ladies of younger generations in fancier dress.

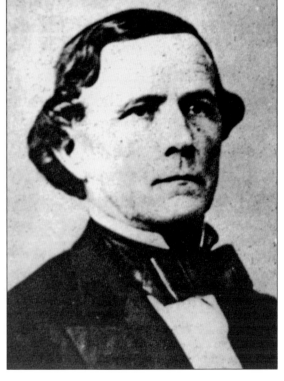

Jones Mitchell Withers was a brother of Susanna Claiborne Clay. He was an attorney and secretary for his brother-in-law, Gov. Clement Comer Clay, and of the Alabama senate in 1838 and 1839. His career included being a planter, merchant, editor, and major general of the Confederate army following his service in the 1836 Indian campaign and the 1846–1848 Mexican War.

The *Southern Advocate* newspaper of Huntsville on June 4, 1857, ran an advertisement for Dr. John Wright Withers, offering his services as a physician in the Madison Station area at the former Eliza Jordan residence. Jordan was the maternal grandmother of Dr. Withers. Her daughter, Palmyra Jordan, was the wife of his father, the senior John Wright Withers (1796–1836).

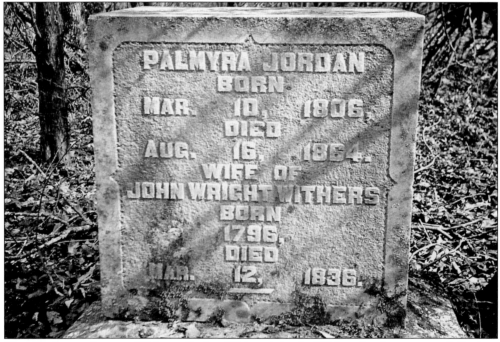

The massive tombstone of Palmyra Jordan Withers is in the Withers family cemetery. It lies in a heavily wooded area just south of the railroad and west of County Line Road in Limestone County, very near old Madison. The family was headed here by John (1770–1826) and Mary Herbert Jones Withers. Their ancestry ties back to Malcolm II, King of Scotland.

Clement Claiborne Clay was the first child of Susanna Claiborne Withers, daughter of John and Mary Herbert Jones Withers. He was born in 1817 on his father's plantation adjoining his grandparents' lands in the Madison area. He attended law school at the University of Virginia, graduating in 1840. In 1842, he was elected to the state legislature.

Clement Claiborne Clay served as judge of the county court, then US senator (succeeding Jeremiah Clemens), and as a Confederate senator (1861–1863). In 1864, he went on a one-year secret mission to Canada for the Confederacy. He and his wife were imprisoned in Fort Monroe with Jefferson Davis after John Wilkes Booth's 1865 assassination of Lincoln.

Virginia Tunstall's early portrait definitely does not do her justice. She was a daughter of Dr. Peyton Tunstall and a niece of the wife of Henry Watkins Collier, in whose Tuscaloosa house Virginia's 1843 wedding occurred while Collier was Alabama Supreme Court chief justice. The Colliers lived in the Myrtle Grove plantation house along the river near Triana.

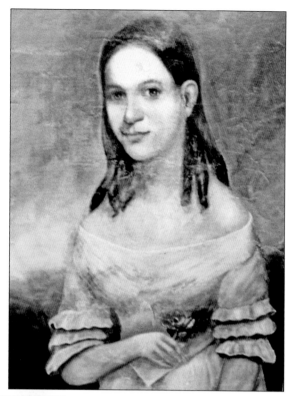

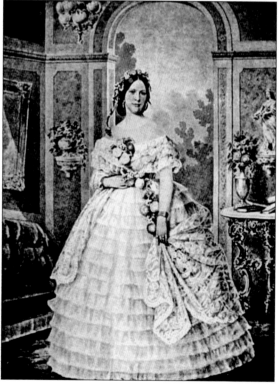

The Clay family photograph archive in the Huntsville–Madison County Public Libary Heritage Room includes this picture of the adult Virginia Tunstall Clay, wife of Clement Claiborne Clay. It shows that she matured into the lady who was widely acclaimed as beautiful and charming in the social circles of the nation's capital while her husband was a senator there in the 1850s. It was there that she developed contacts that later led to her 1865 release from imprisonment.

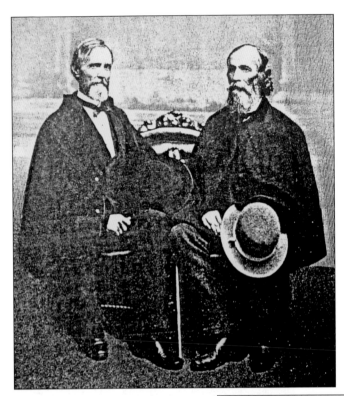

Jefferson Davis (left) and Clement Claiborne Clay were photographed together upon their release from prison after the Lincoln assassination. Clay's wife, Virginia, wrote her memoir *Belle of the Fifties* to describe her life in the high society of Washington, DC, and subsequent temporary imprisonment with her husband, whom she tirelessly worked to get released.

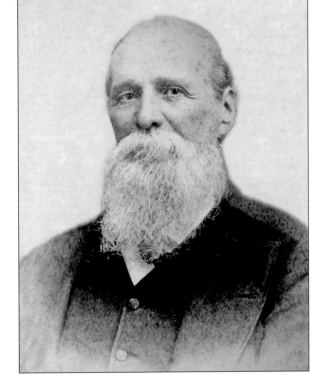

This portrait of John Withers Clay, a son of Clement Comer Clay and brother of Clement Claiborne Clay, was labeled as being painted in 1896—the year of his death. His name memorialized his maternal grandfather. John was an attorney, but became editor of the *Huntsville Democrat* newspaper for 40 years.

A grandson of John Withers Clay is likely shown in this photograph from the Clay family archives. The photograph has a notation that it is of John Withers Clay Jr. in July 1899. Among John Sr.'s sons were Clement C. (born 1848), William (born 1853), and two named John W. (one was born in 1849 but died young, and another was born in 1861).

John Withers Clay (left) is seated alongside his brother Hugh Lawson Clay, an attorney in Huntsville. John's son Willie stands behind his father, while John's son John Withers Clay Jr. is behind his uncle Hugh. At the time of the 1860 census, the John Withers Clay home was near the site of today's Von Braun Convention Center.

An invitation to a 1907 Fourth of July party in the John Withers Clay home includes pictures of three daughters. Here, Susanna "Sue" Withers Clay (born 1858) is seated, while Virginia "Jennie" Clay (born 1863) stands. A third daughter, Mary, was also on the invitation. Daughter Cara Clay apparently died young, appearing only in the 1850 census at age three.

Jennie Clay, shown here, and her sister Sue took over editorship of the *Huntsville Democrat* newspaper when their father became paralyzed. They continued to publish the paper for many years, earning a good reputation for their scholarship, but remaining unmarried. Coincidentally, the 1880 census shows the family living on Maiden Lane in Huntsville.

Mary Clay (born 1854) was the eldest surviving daughter of John Withers Clay. Her picture here is on the July 4 party invitation. She is outfitted in an heirloom dress, according to the notations on the back of the archived photograph. Her sister Cara was born in 1847, but Cara must have died before the 1860 census.

Mary Saunders Clay is depicted in a locket-type photograph at an earlier age than on the 1907 invitation. There are numerous old photographs of the Clay family in archives held at the Huntsville-Madison County Public Library's Heritage Room. Not all of them have notations of the subjects or dates, so some diligence in identification is necessary.

This photograph appears to be of Elodie Clay, youngest daughter of John Withers Clay. Elodie was likely named in honor of her mother's sister Elodie Lewis, daughter of Col. John and Mary Lewis of Huntsville. Elodie Lewis married Samuel Tanner Jr., a younger brother of John Tanner, the namesake of the Limestone County town of Tanner.

The old photograph is labeled as Emily Clay. There was no known Emily in the Clay family, so it is likely another depiction of Elodie Clay. In the 1800s, the Huntsville Clay families would have frequented the Madison-area plantation lands of their ancestors, Gov. Clement Comer Clay and his father-in-law, John Withers.

Two

A Town Is Born

As James Clemens contemplated the route and needs of the Memphis and Charleston Railroad through Madison County, he no doubt was aware of the many past names that referred to the area. Prior to the Indian cessions, this area was known at the Great Bend of the Tennessee River. The State of Georgia had it labeled as Houstoun, but its land claims were set aside by the federal government. As the population of settlers grew in the years leading to the 1850s, the historical location of Madison was simply known as school lands because the site was state-owned as the 16th section of Township 4 South, Range 2 West, reserved for use to fund public education. Before 1850, the number of settlers around the 16th section became sufficient to designate a tax and census district separated from Triana. The new district became known as McElhaney's Precinct or Beat 8 of Madison County. McElhaney was the name of a settler who owned land that is now occupied by Lowe's Home Improvement Center on Highway 72 in Madison.

Clemens purchased most the 16th section of land from the state in 1854. Two months before he died in June 1860, Clemens acquired the rest of the section from William Gooch, who had bought the balance. Clemens founded the town by selling the first lot of his sketched plat in February 1857. He intended that it be named Clemens Depot as his legacy. He even offered the railroad land around a depot in his new town, but for unknown reasons, the railroad maps referred to the depot as Madison Station. Clemens had already hired boys to put fingerboards along the trails and roads in the area, pointing the way to Clemens Depot. Eventually, the boards rotted down after Clemens died. In August 1857, the Beat 8 citizens petitioned to have the voting precinct centered at the depot, so Madison Station became the name of an officially existing town, an embryonic center of commerce.

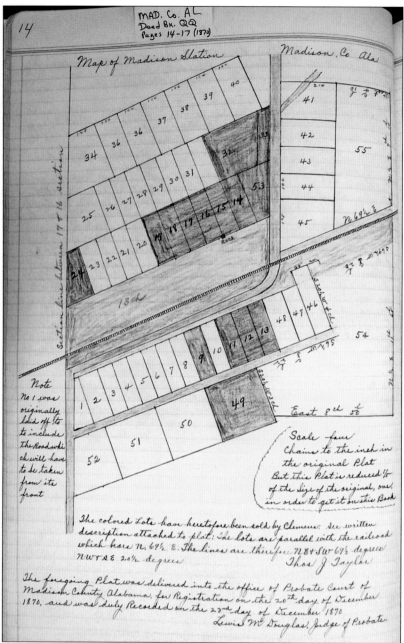

The earliest Madison town plat does not show surrounding plantations. It was originally sketched by James Clemens and then expanded to 55 lots by the executors of his estate for an October 1868 auction to settle the estates' land holdings. Clemens himself sold 15 of the lots before his death, according to the shading and notations on the 1870 plat. The plat shows one lot with no number, lying north of Lot 15 and between Lots 31 and 32. The unnumbered lot was purchased by Thomas J. Clay at the October 1868 auction, along with Lots 53 and 32. He already owned Lots 14 and 15 by record of his 1857 purchases from Clemens. Clay's initial store location was probably on Lot 14 or 15, but later records mention his storehouse on the unnumbered lot, after Lots 14, 15, and 32 were sold to Frank Hertzler's wife, Marietta Sullivan, and others.

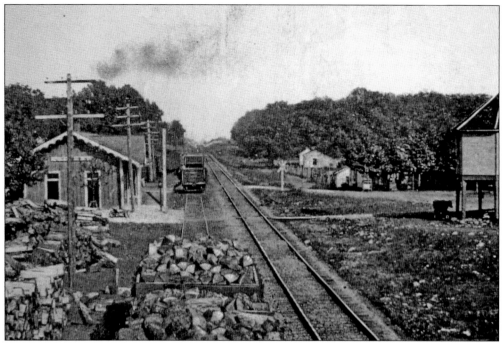

The earliest Madison depot photograph shows the Roundhouse, which was actually octagonal, across the tracks. Notice two sets of tracks in front of the depot. There was another set of tracks running behind the depot for freight loading and unloading. Beyond the depot, towards the east, is the Church Street crossing of the tracks, approaching the junction with today's Main Street.

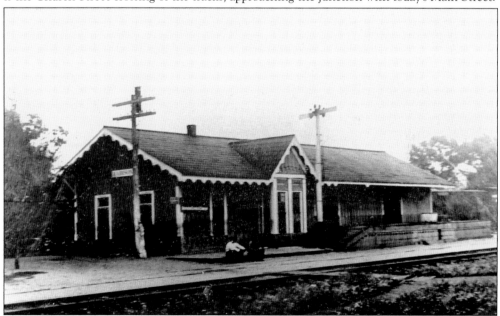

A later depot, thought to be photographed about 1930, has an updated appearance. It is believed to be the fourth depot on the site due to destruction and fires of earlier versions. The first depot was destroyed by a Confederate attack on occupying Union troops. The depot was barricaded with cotton bales as a fort, but Union troops fled from Confederate cannon fire in May 1864.

The one-story portion of this house, located at 19 Front Street today, was the home of Madison's first railroad depot agent, physician William Barham Dunn. It was incorporated into the James Edward Williams house as a north wing around 1905 after being raised and turned 90 degrees to face west. It probably dates back to 1868 or earlier, quite possibly even to 1860.

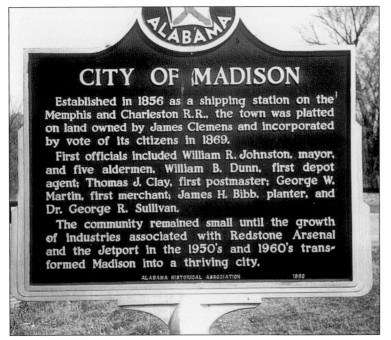

CITY OF MADISON

Established in 1856 as a shipping station on the Memphis and Charleston R.R., the town was platted on land owned by James Clemens and incorporated by vote of its citizens in 1869.

First officials included William R. Johnston, mayor, and five aldermen, William B. Dunn, first depot agent; Thomas J. Clay, first postmaster; George W. Martin, first merchant; James H. Bibb, planter, and Dr. George R. Sullivan.

The community remained small until the growth of industries associated with Redstone Arsenal and the Jetport in the 1950's and 1960's transformed Madison into a thriving city.

ALABAMA HISTORICAL ASSOCIATION 1993

The Madison historical marker was installed on the Village Green at the junction of Church and Front Streets, the north side of the railroad. After needed repairs from damage by vehicular traffic are completed, it will be installed on Main Street. The marker commemorates the 1869 incorporation of the town with the name Madison, rather than Madison Station.

Leadership of the Madison Station Historical Preservation Society, headed by Jeanne Steadman, applied for and received approval for Madison Station Historic District to be added to the National Register of Historic Places after compiling sufficient documentation of the history of the town and its structures in the business and historical residential areas in 2006.

In 1890, a Hartford Insurance representative documented Madison's business district, sketching a color-coded map depicting structures, materials of construction, and insurance policy premiums. Owners are named, and outlines of the structures are illustrated. Main Street was called Broadway Street then, and Front Street was North Rail Road Street, having earlier been the path of an actual railroad track.

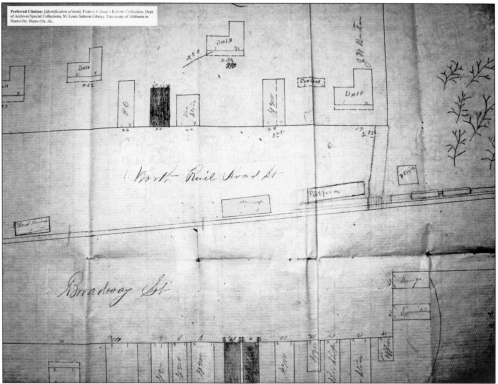

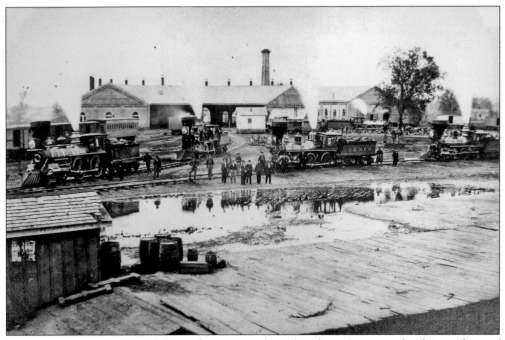

Transportation of cotton, freight, and passengers by rail and riverboat was the driving force of Madison's commerce from its early days. Until trains entirely replaced the riverboats, they were used together to carry cotton and other goods to and from the river ports. The Huntsville depot and maintenance shops were the hub of the railroad in this area, as shown in this 1860 photograph.

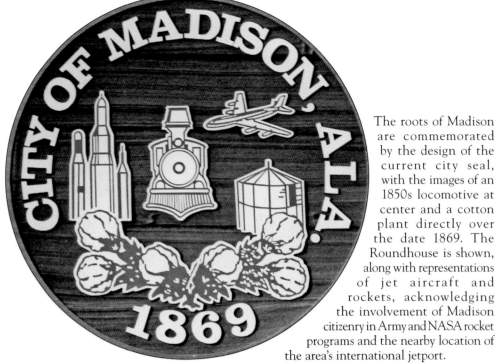

The roots of Madison are commemorated by the design of the current city seal, with the images of an 1850s locomotive at center and a cotton plant directly over the date 1869. The Roundhouse is shown, along with representations of jet aircraft and rockets, acknowledging the involvement of Madison citizenry in Army and NASA rocket programs and the nearby location of the area's international jetport.

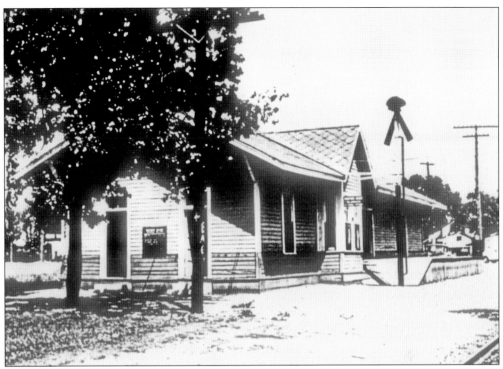

The last railroad depot in Madison was built in 1901, closed in 1961, and torn down afterward. It had been preceded by the first depot (1856–1864), the second depot (1866–1885), and the third depot (1885–1901). The first one was burned during a driving rain in the course of the Confederate attack on Union forces in the town on May 17, 1864.

Madison students took the last passenger train to Huntsville before depot closure in 1961. The adult at the left is Edna Haygood. Third girl from left, with white gloves, is Patsy Spencer. Margaret Sides is the fifth girl from the left, with a big smile and white head covering. Jean Brazelton is the short girl with a purse at her feet. The others are unidentified.

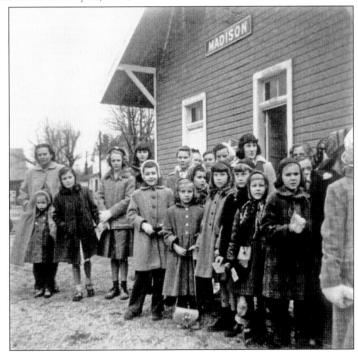

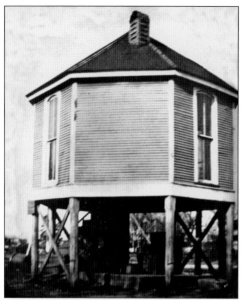

The original Roundhouse was built over the town's cistern south of the railroad tracks, at the north edge of Main Street and east of Main Street Café's outside seating now. The Roundhouse was constructed in 1898 at the request of the mayor for an office. It became not only the city hall, but also a card-playing parlor and place for the occasionally visiting barber to cut hair. It was torn down in 1936.

The Roundhouse probably got its name from train passenger assumptions that it served a railroad function. A 1986 replica was constructed at the former depot site as a community project during the first annual Street Festival. Here, Madison Belle enactors Joylyn Bukovac (left) and Alecia Eidsaune review the Madison sesquicentennial book inside the Roundhouse Replica Museum.

Cavalry captain John Buchanan Floyd was mayor in 1898. He had been wounded in an ankle at the Battle of Big Shanty, defending Atlanta, so his daily walks up the Roundhouse stairs would have been painful. He was mayor until 1900, when B.F. Harper took office. In 1885, Captain Floyd and others chartered the Madison Male and Female Academy along today's Pension Row.

Small for its day, the home of Captain Floyd was situated at 18 Martin Street, only about two blocks from the Roundhouse. The house still stands, occupied for years by Madison native Vivian Bell Landers, who worked on the Alcan Highway in Canada with the Army Corps of Engineers and, later, at Redstone Arsenal. She joined NASA on the Saturn/Apollo program as a computer systems analyst.

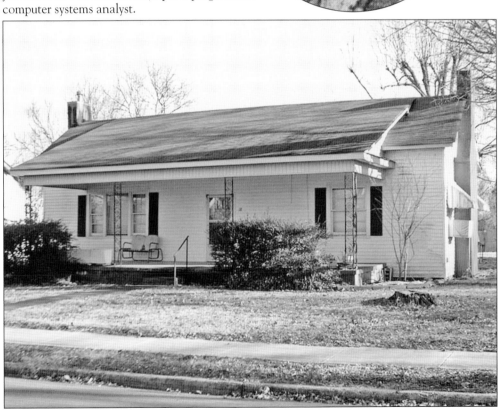

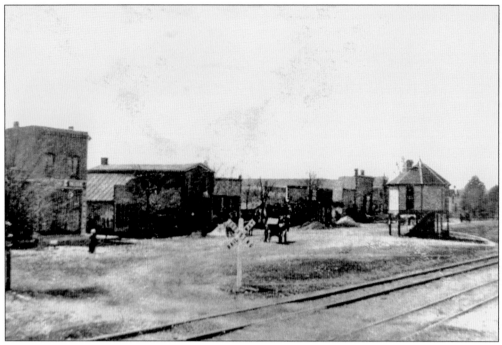

This c. 1900 photograph of Madison is copied from a postcard found at a flea market in Nashville by Kip Taylor of Taylor Electric Service in Madison. The photograph was apparently taken at the south end of Church Street by the railroad tracks. It shows horse-drawn carriages, the original Roundhouse, and the Burton and Wise Drugstore.

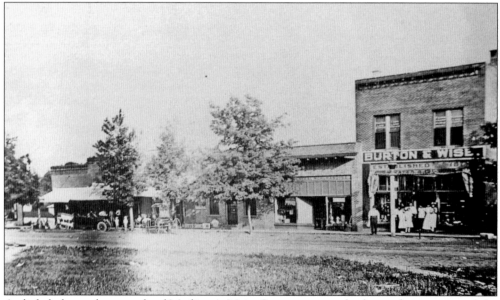

A slightly later photograph of Madison's Main Street apparently shows the opening of the Burton and Wise Drugstore at Main and Garner Street. The pharmacy of John Winston Burton was opened in 1871 at the east end of Main Street. Following the 1904 death of John Winston Burton, his son John Mullins Burton moved the business in 1908 to this site with partner George Washington Wise.

Three

THE BUSINESS DISTRICT

Some of the older structures of Madison's original business and historical district have withstood the tests of time. Some are badly deteriorated now, and others are truly gone with the wind. According to older residents, the town has had two significant fires in the district. The stores on the east end of Main Street burned in 1924. Another fire occurred in 1942 on the western end of the business row at Wise and Main Streets. Still, family stories and old photographs, plus a few other sources, help to identify how the town looked in years gone by. Fortunately, there even remained sufficient information for Madison's acceptance in the National Register of Historic Places in 2006.

There are stories of a humorous nature associated with the commercial enterprises, but there were also great tragedies, including loss of life in the business district. One of the humorous items has to do with the Bank of Madison advertising itself as "unrobbable" due to its state-of-art vault structure and locks, as well as protection by the Pinkerton Detective Agency in the early 1900s. Yet it was burglarized one night with the use of an acetylene torch. What were called "crispy bills" got circulated in the town for a time. Another incident was when the town pharmacist—George Walton "Doc" Hughes, who was also mayor—chased a lawbreaker from the town, both men shooting as they ran. The town was peppered with shots, but nobody was harmed. On the other hand, fatal accidents associated with the railroad also occurred. On two different occasions, women of the town were killed while crossing the tracks near the depot. One of the victims was the mother of the depot agent at the time. Another was the wife of one of the leading town merchants, and her young son drowned in a cistern behind the family store just a few months after her death. Tragedies, joys, and humor can be found in the history of families and towns throughout time, including that of Madison.

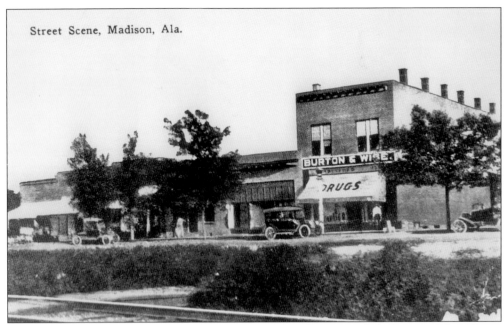

Street Scene, Madison, Ala.

This scene along Madison's Main Street by the 1920s and 1930s included automobiles. This is another old postcard photograph showing the Burton and Wise Drugstore at Main and Garner Streets. The store buildings shown along Main Street to the east (left) of the drugstore are still standing, as are more to the west of the business.

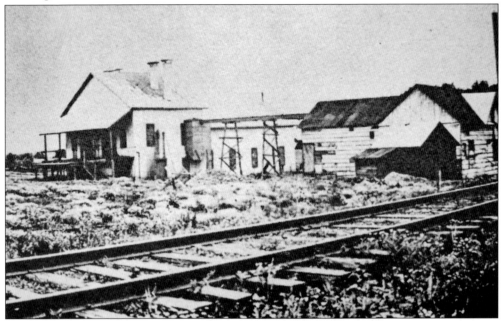

The Farmers Cotton Gin stood on the west side of Sullivan Street, south of the railroad tracks and beyond the western end of Main Street. It was a center of activity in the town during cotton harvest time. There were four such gins in Madison in the early 1900s. The electrically operated Brewer Gin still stands—but just barely—situated east of the Animal Trax shop and the North Alabama Gas District office.

In this eastward view of the Farmers Gin, also known as the Whitworth Gin, the old Madison water tank is visible in the background, above the heads of the mules on the right. That water tank was built in 1936 and taken out of service in 1979. It was 135 feet high and held 75,000 gallons of water.

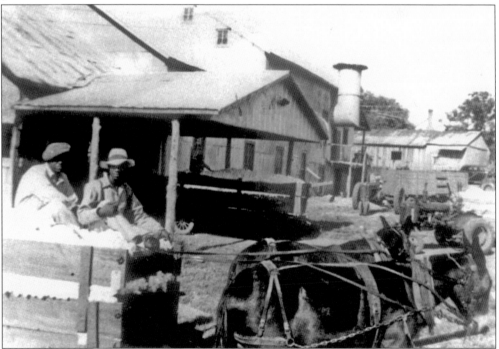

Here, cotton is being brought to the Whitworth Gin in a wagon pulled by mules. On the left is Gilbert Hewlett. His companion is Willie Pope. There was also a blacksmith shop in the background. Madison has been home to several gins over the years, including the Brewer, Farmers (Whitworth), Planters, Valley, and Home Gins.

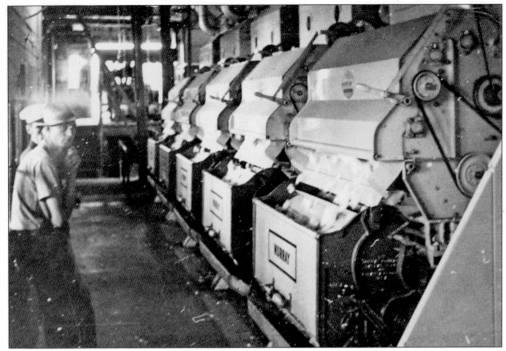

The cottonseed removal stage of operations inside the Farmers Gin is shown here. The cotton gin was owned by John David Whitworth, one of the local descendants of Daniel Whitworth, who settled near Triana in the pioneer days. Many of the Whitworth and related family members still reside in Madison.

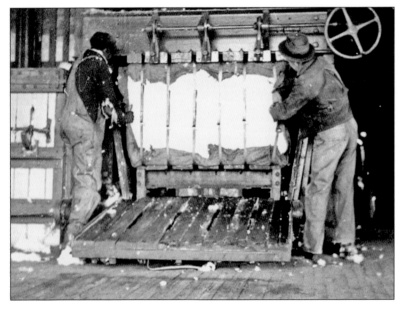

The cotton cleaned of seeds and debris eventually went to a press to make the large bales. Here, the press is attended by two men, neither of whom is identified. The bale is about to be removed, marked, and prepared for release back to the owner or for shipment from the gin's loading dock.

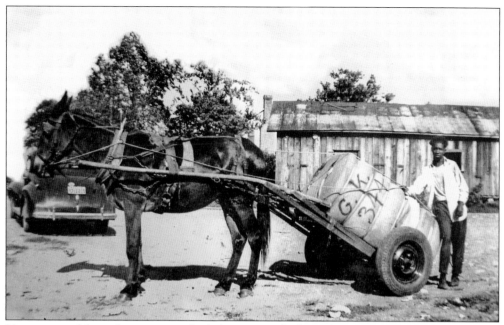

Upon removal from the gin press, the bales were pushed or otherwise transported to a loading dock at the gin. Cotton gins typically did not have large docks to hold many bales. Here, after the days of the riverboats had passed, George Washington Bradley prepares to transport a cotton bale to the rail loading dock or to some other storage area.

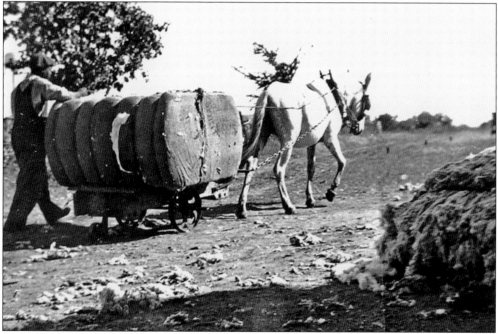

Before the railroad completely replaced river traffic for shipping cotton to distant mills, paddle wheel steamboats were used on navigable rivers. Since the river port was in Triana, the bales had to be transported overland to that point. Sometimes, the bales would be stored for a time in cotton barns, awaiting better market prices.

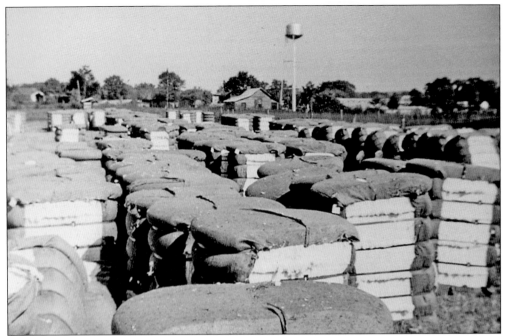

Cotton bales went to railroad stations for shipment to remote markets and mills. Many of the Madison-area bales were destined for Huntsville's cotton mills to produce spindles of threads for the textile mills and related manufacturing. Cotton mills, as humid hotbed incubators of tuberculosis from the 1850s, were far more dangerous to workers than were cotton gins.

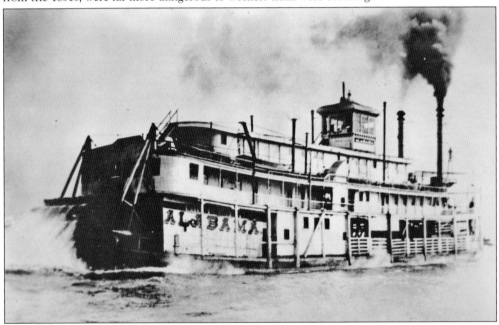

The steamboat *Alabama* is seen here underway at full speed on the river. It is heavily loaded, as evidenced by the gunwales sinking deep toward the waterline. This boat was used to accommodate passenger traffic in times when cotton freighting was not the primary activity. That kept operators in business most of the year, bringing travelers, news, and goods to the area.

Speculators as well as farmers stored cotton bales throughout the town. This is the cotton barn of Madison merchant Robert Cain. It was located at Garner and Main Streets; today, the site is a municipal parking lot location. Family records relate that even justice of the peace Elijah Thomas Martin stored cotton bales in his house on Martin Street at one point, awaiting better market conditions.

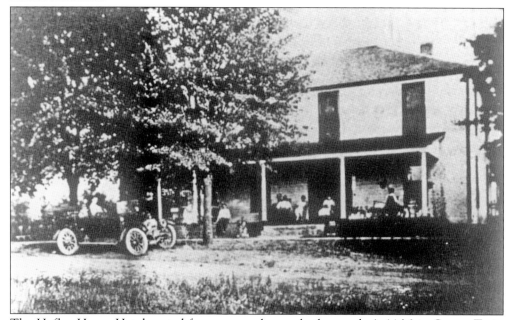

The Hafley House Hotel, noted for great meals, was built at today's 14 Main Street. Train passengers as well as local citizens frequented the establishment. William Hafley, a former grocer from Decatur, was listed as the hotel operator in 1910. In 1920 Madison, he was a grocer again. His daughter Ellie was listed as a grocer in Madison in 1930.

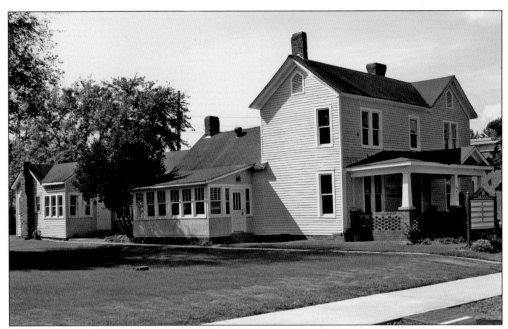

Bought just after the Civil War by Sarah, widow of Confederate soldier Andrew Clay, the 16 Main Street site was deeded to the Presbyterian Church as a poorhouse for widows and orphans of Confederate veterans. It subsequently was used at times as a hotel, hospital, mortuary, medical office, family residence, museum, and art gallery. It now houses a variety of additional businesses.

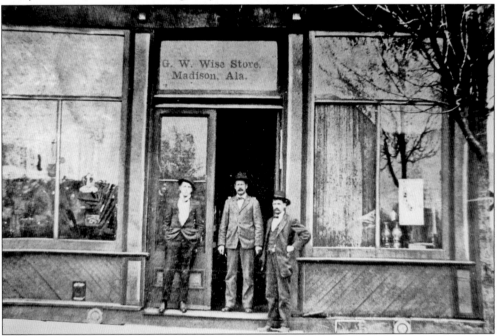

The store of George Washington Wise occupied the site of 20 Main Street. He is pictured in the middle in this postcard. The men on either side of him are unidentified, but one is most likely his brother and business partner, James Arthur Wise, who lived at 16 Main Street for a time. George was a son-in-law of Madison's first merchant, George Washington Martin.

George Washington Wise married Hattie Martin, a twin of Hassie. They were daughters of George Washington Martin, Madison's first merchant and lot owner. Here, Madison Belle enactor Juliana Johnson puts flowers on Hattie's grave in the old section of Madison's city cemetery, just south of Mill Road and east of Maple Street.

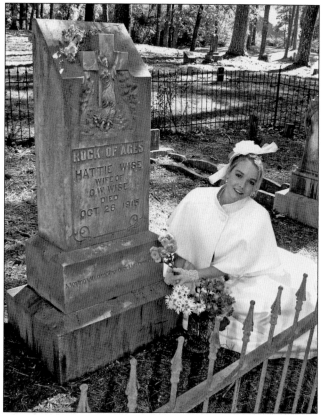

One of the historical treasures of old Madison is the 1888–1889 transaction ledger of George Washington Wise's store. Purchases of just about everyone who lived in Madison were recorded, at least for items bought in Wise's store. Most ledger entries were written by George's sister-in-law, Mattie Martin, who married James Albert Watkins and worked in Wise's store.

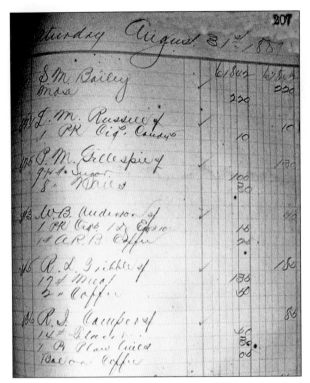

This excerpt from page 207 of the Wise store ledger is dated August 31, 1889. It records the purchases on that day of members of the Bailey, Russell, Gillespie, Anderson, Tribble, and Camper families of Madison. Other pages of the ledger keep a running total of charges and payments for each family's total account in the year.

James Albert Watkins worked for a time with his wife, Mattie, in the Wise store. Mattie was his second wife, following Emma Pride Watkins, who died in 1886 after birthing three children. Mattie lived to age 96, dying in 1955. James was a trustee of the Madison school when it incorporated in 1895. He also served as county commissioner from 1900 to 1907, dying while in office.

The house of George Washington Wise is gone with the times. It stood at the southwestern corner of Martin and Garner Streets. Hattie Martin Wise's mother was Nancy Leeman, wife of George Washington Martin. Nancy was killed by a train in 1891 when crossing the tracks at the depot while her son Berry Leeman Martin was the depot agent.

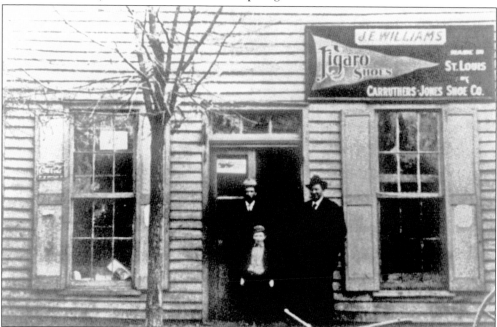

The parking lot at the corner of Wise and Main Streets was the site of the James Williams store. He is on the right, his son Tillman Williams Sr. is in the middle, and Pryor Bailey Farley is in the doorway. This store burned in 1942 from a restaurant fire in the building. In 1883, Williams began working as a sharecropper at age 16. He eventually became Madison's wealthiest man of his time.

The only structure with a street address on the north side of Main Street is now the Main Street Café at 101 Main Street. It was built in 1954 as the third Madison City Hall, containing city offices plus the jail and parking space in the center for the fire truck that was purchased in 1948. The restaurant still has seating inside some former jail cells.

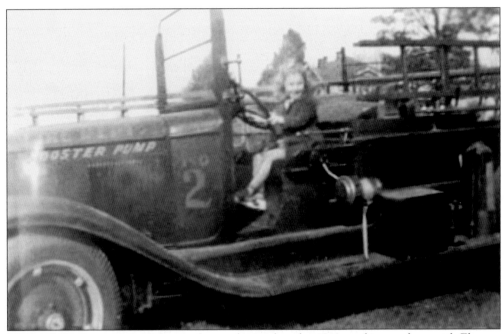

Madison's first booster pump fire truck was obtained in the 1940s and is seen here with Eleanor Ann True behind the wheel. Eleanor is a daughter of Gladys Naomi McFarlen True, a primary Madison historian of the later 1900s. Gladys and her husband Robert Edgar "Pud" True operated a grocery store in Madison for 35 years at 208 Main Street.

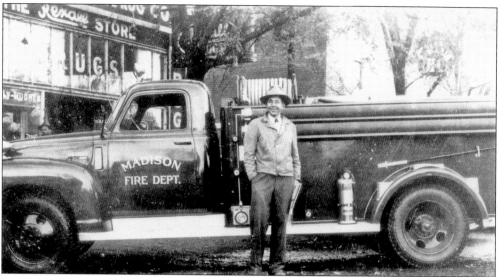

This fire truck, purchased by the city in 1948, is shown in front of the Humphrey-Hughes Rexall Drugstore at 200 Main Street. George Walton Hughes, better known as "Doc" Hughes the pharmacist, first rented, then owned the building from 1925 to 1972. Hughes was mayor from 1944 to 1949, during which time the truck was purchased. He stands beside it.

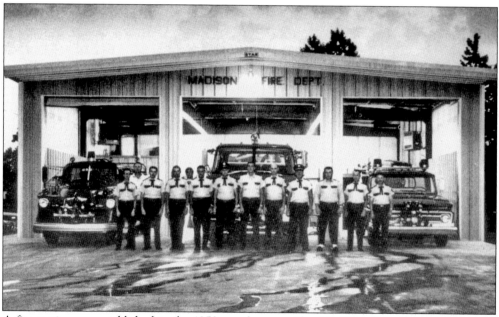

A fire station was established in the 1950s on the west side of Sullivan Street, just north of the intersection with Palmer Road. Shown, from left to right, are Claude Sturdivant, Bill Turner, Terry Duncan, Don Spencer, David Nunley, Rex Bearden, Nolon Wilkes, Stuart Wells, Alton Craig, Chief Charles Wallace, Mike Kloster, Roy Hood, and Bill Mooney.

The brick building at 104 Main Street survived the 1942 fire to its west that burned the Jim Williams store along with the restaurant in it. The store of Douglas Broyles and the barbershop of Robert Shelton at the 100 and 102 Main Street locations also burned. Billy Nolan Drake, grandson of Williams, had his office at 104 Main Street until it became the Whistle Stop Sweet Shop in 2012.

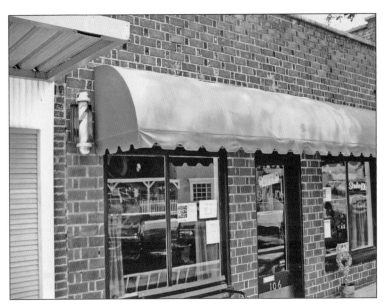

In recent years, 106 Main Street housed Salon 106. Now, that shop has moved to 16 Main Street. Earlier, the 106 Main Street location contained a post office annex. After the 1942 fire, it became the new site of the Shelton Barbershop, operated by Robert Shelton and then by his son Hoyte, who lived at 114 Church Street in the 1990s.

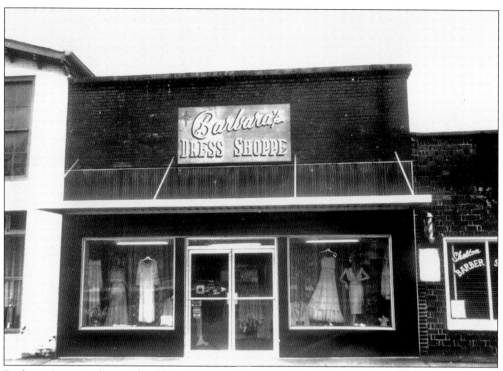

Barbara Ann Hughes, wife of Don Spencer Sr., operated a dress shop at 108 Main Street. The building had earlier housed the general merchandise store of James Bronaugh from around 1910. According to a 1913 newspaper, Bronaugh owned two large farms with 90 mules. He also bought the Hafley House Hotel and owned horses that won many races in America.

The 1939 yearbook (*Reflector*) of the Madison school shows the sophomore class picture on page 18. Barbara Ann Hughes is second from the left in the first row. Her cousin Marion Hughes (who married Gene Anderson of Hughes Hardware) is the first person in the second row. Mayme Louise Dublin is the third person in that row.

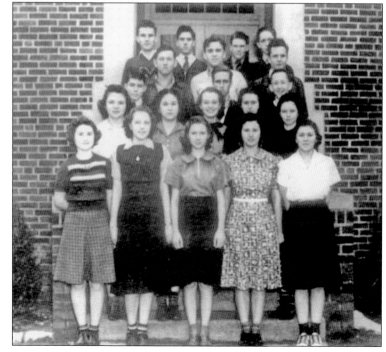

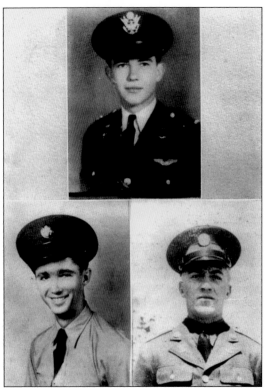

The 1944 school yearbook includes an "In Memoriam" page dedicated to Madison High School students killed in action in World War II. Pictures of Capt. Ollie Wikle Jr. (top), Sgt. Harry Landers (bottom left), and Sgt. Murphy Bates are shown on the memorial page, with text provided on the next page of the yearbook.

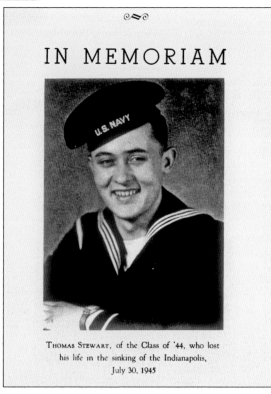

IN MEMORIAM

Thomas Stewart, of the Class of '44, who lost his life in the sinking of the Indianapolis, July 30, 1945

Madison High School graduate Thomas Stewart, class of 1944 and a sailor on the Navy cruiser USS *Indianapolis*, is memorialized in the 1946 school yearbook. The *Indianapolis* was sunk by a Japanese torpedo soon after delivering critical parts of the first nuclear bomb to be dropped on Japan. The ship sank in 12 minutes, and of the 1,196 crewmen, only 317 were rescued four days later.

Jesse Ollie Wikle Jr. was the namesake of Madison's veterans park at Church and Front Streets. Just weeks after this article appeared in the local newspaper, he was promoted to captain. He died in 1942 when his B-17 Flying Fortress was shot down over Tunisia. He named his B-17 "Flaming Mayme" for his girlfriend: red-haired Mayme Louise Dublin, daughter of Clyde Dublin, another city park namesake.

Jesse O. Wikle In Africa Fight

Madison Boy Is Pilot Of 'Flaming Mayme', Account Of AP Reveals

Lieutenant Jesse O. Wikle, Jr., son of Dr. and Mrs. J. O. Wikle of Madison, is the first Madison county boy to have the distinction of participating in the battle for Tunisia.

He has been in foreign service approximately six months, most of it in England.

Lieutenant Wikle received his B.A. degree from the University of Alabama in January, 1941, and con-

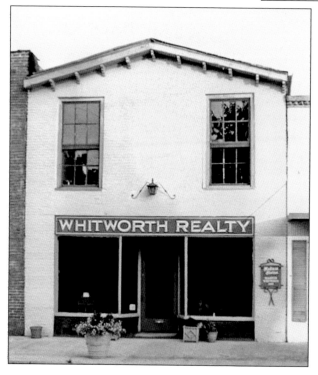

The oldest store in Madison was owned by George Washington Martin, Madison's first merchant and lot owner from February 13, 1857. Believed to have been rebuilt with brick around 1859, it was later operated as a saloon by the Monroe Hardage family. After that, it was the store of Robert Parham Cain and then his son Robert Earl Cain. More recently, it was the realty office of Sara Landman Whitworth.

Sara Landman, a descendant of Madison County pioneer William Landman (buried on Redstone Arsenal) in 1950 married Thomas Whitworth, who was related to Jim William's wife, Mattie Whitworth, a resident of 19 Front Street. Thomas and Sara lived at 12 Main Street. Sara operated her realty office at 110 Main Street for many years before passing in 2008. Her veterinarian son Charles remains in the town.

George Martin announced his business move from Triana to Madison in a May 1857 newspaper ad. He was born in 1820 on Rainbow Mountain, which is within the city limits of Madison today. The Martin family moved there in 1808, while the area was still legally Indian lands. George married Nancy Leeman, granddaughter of William Leeman, an operator of Leeman's Ferry on the Tennessee River.

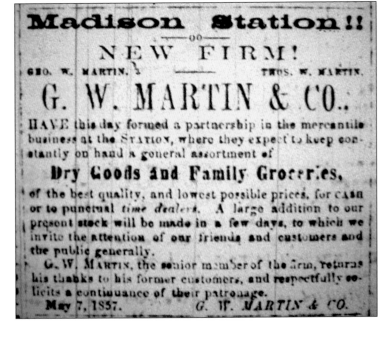

Madison Station!!

— oo —

NEW FIRM!

GEO. W. MARTIN. THOS. W. MARTIN.

G. W. MARTIN & CO.,

HAVE this day formed a partnership in the mercantile business at the Station, where they expect to keep constantly on hand a general assortment of

Dry Goods and Family Groceries,

of the best quality, and lowest possible prices, for cash or to punctual time dealers. A large addition to our present stock will be made in a few days, to which we invite the attention of our friends and customers and the public generally.

G. W. Martin, the senior member of the firm, returns his thanks to his former customers, and respectfully solicits a continuance of their patronage.

May 7, 1857. G. W. MARTIN & CO.

The large "Balanced Rock" on the west side of the Rainbow Mountain summit is said to be the only natural structure of its kind east of the Mississippi River in America. Since he was born on the mountain, George Washington Martin would have known it well as a youth. In this 2007 picture, Mike and Rachel Doherty explore the nature trail beside the rock with their children Zack and Maddie.

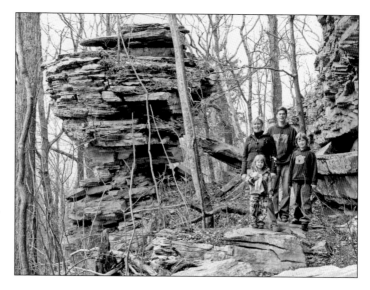

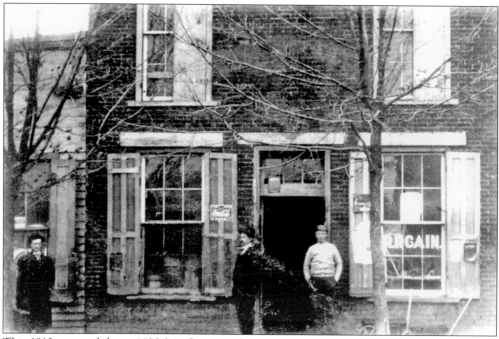

This 1910 postcard shows 110 Main Street as the store of Robert Parham Cain, whose wife, Lena Martin, was a daughter of George's brother Elijah Thomas Martin. Elijah was a noted sharpshooter who rode with Gen. Nathan Bedford Forrest. He was a longtime justice of the peace in Madison, a thoroughbred horse owner, racer, and trick-rider, and a moonshiner.

After the 110 Main Street store passed to Robert Earl (son of Robert Parham Cain), his wife, Annie Nance, was killed in an April 1928 collision at the Sullivan Street crossing of the then double tracks. She had waited for one train to clear, but she failed to notice another approaching from the opposite direction. She was age 34, leaving her husband, a six-month old daughter, and a four-year old son.

Lena Martin Cain's aunt Nancy Leeman Martin died in 1891 while crossing the tracks at the depot. Lena's cousin and twin of Hattie, Hassie Martin Andrews, and her husband died in a 1917 train-auto collision in Texas. Lena's grandson Robert Earl Cain Jr. drowned at five years old in a new cistern behind his father's store in January 1929, nine months after his mother's death in the train-auto collision.

The 110 Main Street store has seen a variety of businesses, and now it has been restored to its historical ambiance as Madison Station Antiques, operated by Ronnie Williams. Signage commemorating ownership by Robert Parham Cain was incorporated into the renovation, but somehow, the sign-maker used the spelling "merchantile" in the new sign rather than mercantile.

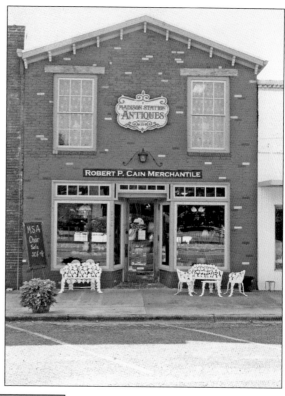

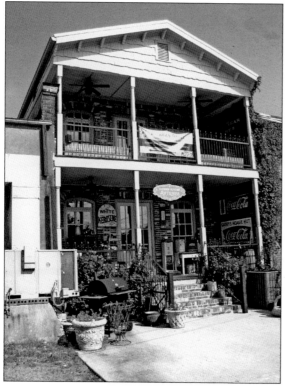

The rear entrance of the 110 Main Street Madison Station Antiques shop has been vastly improved, upgrading the appearance of much of the backstreet Madison business district. The architecture reflects the early history of the building, and the decor utilizes antique signs from the old days. A banner promotes regular "Picker's Alley" events.

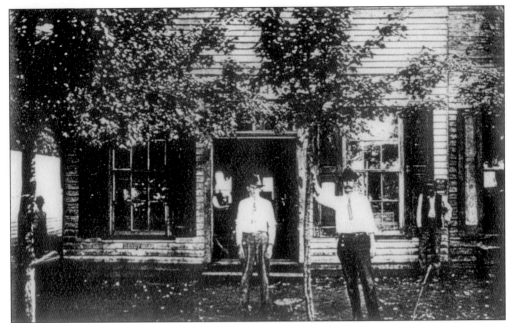

Annie Mae Humphrey Drake provided this old photograph of the first (wooden) store belonging to her father, William Benford Humphrey Sr., at 112 Main Street. His middle name is often seen as "Binford." William is shown in the doorway. The man leaning on the tree has been identified as Clifton Canterbury. The other two individuals are unidentified.

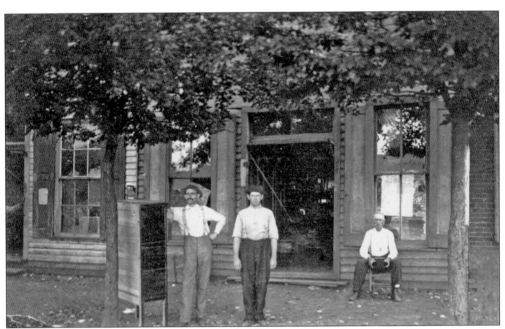

An older photograph of the Humphrey store at 112 Main Street shows men believed to be, from left to right, Clifton Canterbury, William Benford Humphrey Jr., and Elijah Thomas Martin. Martin was known for his precisely scheduled card playing every day near the train station in front of the store.

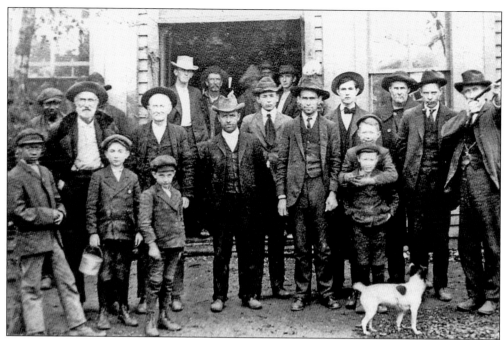

Some of the men gathered around 1906 at 112 Main Street can be identified. In the second row (mostly adults, behind three youngsters at left), from left to right, the man with a beard is unidentified, next is William Hafley, then Henry Humphrey, Robert Earl Cain, Arthur Wikle, William Benford Humphrey Sr., and Elijah Thomas Martin. The dog belongs to William Benford Humphrey Jr., the boy with Wikle's arms around him. All others are unidentified.

The wooden store building of William Benford Humphrey Sr. was moved back toward Martin Street and used as an automobile repair shop by William Jr. William Sr.'s new brick store was built around 1919 at 112 Main Street. It was West Station Antiques in the 1980s and 1990s, then Hale Fire Glass afterward. Today, it is unused.

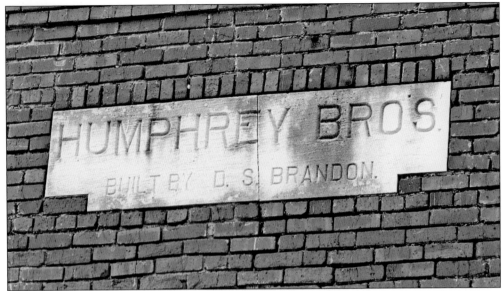

The concrete sign set into the bricks over the door at 112 Main Street reflects that William Benford Humphrey Sr. had his brother Hermon as a partner. They were sons of James Alexander Humphrey. According to family tradition, James was a noted carpenter and builder of the original Roundhouse.

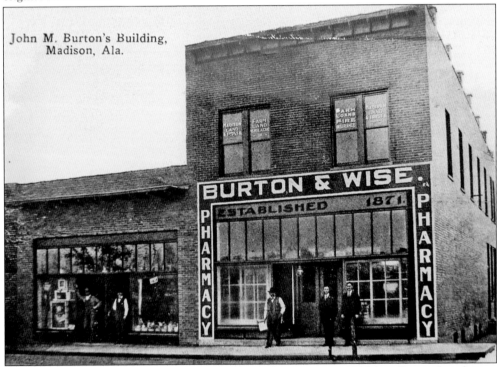

John M. Burton's Building, Madison, Ala.

In this 1913 photograph of the drugstore of John Mullins Burton at 200 Main Street, the adjacent building that later housed the store of James Henry Cain at 202 Main Street is also pictured. Shown are, from left to right, Tom Logan Bradford, unidentified, Burton, Douglas Broyles, and E.W. Teague.

After John Mullins Burton died in 1924, his estate was managed for a time by Hermon Humphrey and, from 1925, by Hermon's widow, Cora Mae Lewis. The Humphrey brothers (of the store at 112 Main Street) apparently operated the drugstore for a time, with a sign reading "Humphrey Brothers" over it. Doc Hughes worked there, began renting it, and then bought the building from Fannie Burton Bradford.

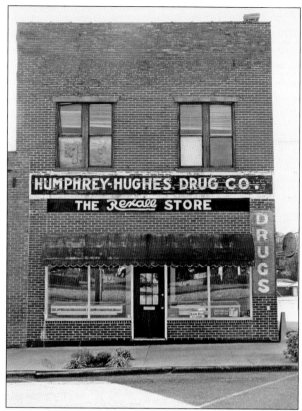

This 1909 postcard photograph shows, from left to right, Robert Parham Cain (1867–1923), John Edward Humphrey (1897–1974), John Longstreet Humphrey (1866–1921), and Chappell Cain Humphrey (1902–1920). The card was written by James Henry Cain to John Mullins Burton, who was a cousin of brothers James Henry and Robert Parham Cain.

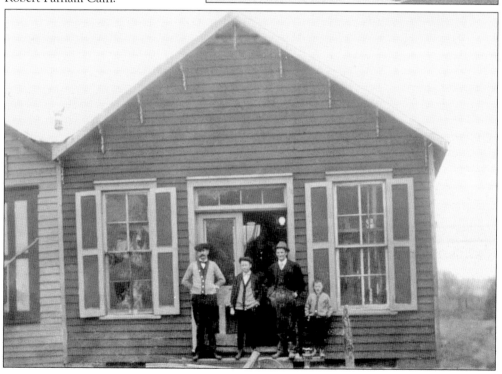

This picture has Doc Hughes preparing for the "Christmas Capers Chicken Toss," when chickens with leg bands redeemable for merchandise at 200 Main Street were released on Christmas Eve to fly from the roof. After John Mullins Burton died in 1924, his store was to be sold, according to his will, with Hermon Humphrey as executor. Hermon died the next year, in 1925.

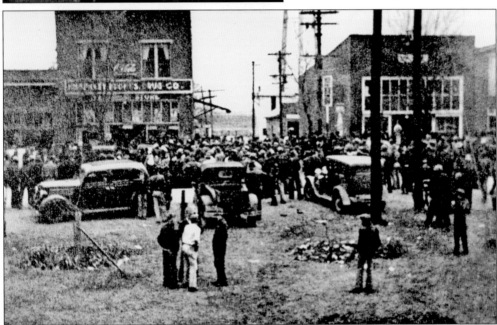

A photograph from the Great Depression era shows the Christmas Capers Chicken Toss crowd on Main Street. At the back of the alley on the right side, part of the second city hall can be seen as a white two-story building, with legs of the water tower rising above it. The sign over the drugstore still shows it as the Humphrey-Hughes Drug Company. The building had apartments for rent on the second floor.

The water tank behind the second city hall, located at Garner and Martin Streets, was used for the Christmas Capers Chicken Toss after its 1936 construction. Doc Hughes rented the building at 200 Main Street before buying it from Fannie Burton Bradford, daughter of John Mullins Burton and widow of Tom Logan Bradford. Tom committed suicide in January 1918.

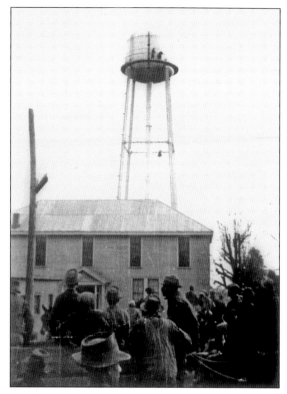

A lucky catcher of one of the chicken tosses is shown here. The chickens could fly, but not far, and whoever caught one redeemed the leg band for merchandise and had a chicken dinner at Christmas. For some, this was the only Christmas present received. John Mullins Burton would probably have been pleased to see these crowds around his building attracted by Doc Hughes.

Another unidentified but lucky recipient of the Christmas Capers Chicken Toss takes his prize through the streets near 200 Main Street. Burton's store ledgers for 1905 to 1907 have been microfilmed and are stored in the Heritage Room of the Huntsville–Madison County Public Library. The 200 Main Street location had offices and apartments on the second floor, which also housed the telephone exchange until 1942.

In the upper right corner in this early aerial view of Madison is the second city hall, a two-story structure located one block behind Main Street. Across Garner Street from the city hall is Robert Cain's cotton barn (front view on page 51). Note the unpaved streets, the depot and icehouse at left, railroad tracks behind the depot, and a freight platform at the bottom right.

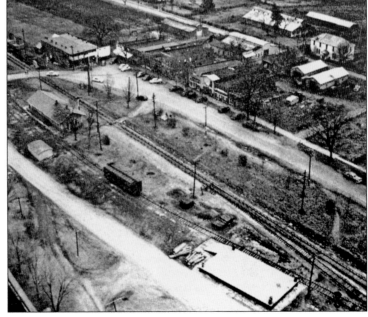

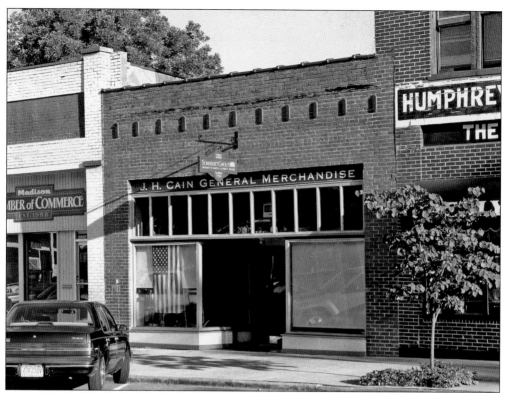

James Henry Cain had his store at 202 Main Street, for a time part of his cousin John Mullins Burton's drugstore. Cain married Charlotte "Lottie" Slaughter, daughter of Dr. John Robert Slaughter and his wife, Mary Lanford. Mary and Lottie were both born and raised in the Lanford-Slaughter house at 7400 Old Madison Pike on the east side of Indian Creek.

The J.H. Cain sign above the door of 202 Main Street was covered for many years and forgotten. During renovation as part of the Noble Passage Interiors and Gifts store, the sign was rediscovered and is now prominently displayed to reflect days gone by. Cain bought a large house for his bride at 18 Arnett Street.

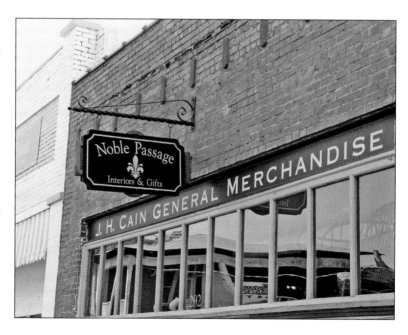

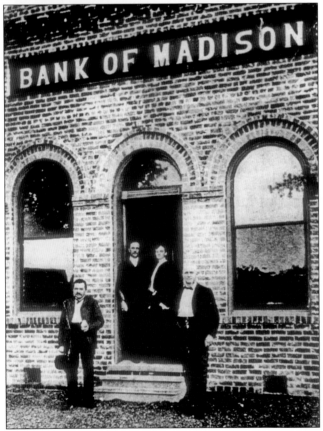

About 50 or so years ago, the store at 202 Main Street was used as a dress shop by a person that some reports identify as Mable Sawyer. Other notations show her as Mable Patterson. The store also was operated by William J. Wann and then by widow Woodie Latham Collier and her sons in the early 1930s. James Cain married Woodie Collier in 1937 after divorcing Lottie in 1936.

Madison's first bank, incorporated in 1905, was at 204 Main Street. This photograph was for a time framed on the wall in Madison's current city hall. It had a legend plaque identifying those pictured as, from left to right, John Winston Burton, tellers Mr. and Mrs. Si Hager, and Harvey Anderson; however, John Winston Burton died in 1904. His son John Mullins Burton actually stands at far left.

Matthew Harvey Anderson was a director of the bank according to a 1913 newspaper article. George Washington Wise was its president at that time. The bank was advertised in newspapers as "unrobbable" and protected by the best lock mechanisms, as well as the Pinkerton Detective Agency. Still, it was burglarized one night: robbers broke through the back wall using an acetylene torch.

After passing through two vault doors into the main storage chamber, there are two additional small safes along the lines of today's safe deposit boxes, only larger. The yearly inspection stickers are still stuck on the frame of the main door to the vault, intact today inside the Noble Passage Interiors and Gifts store at 204 Main Street.

Dea Theodore Thomas had this store at 206 Main Street. He entered the mercantile business in 1904. His store was damaged by a fire in 1912 that also destroyed the 208 and 210 Main Street buildings. Thomas died in 1917, and his brother-in-law William J. Wann ran the store until 1940, when the post office was moved to this location. J and B Electrical was here in the 1950s to the 1970s.

Frank Hertzler and Matthew Harvey Anderson (Frank's brother-in-law) had a hardware store at 208 Main Street. The store burned in 1912 but was rebuilt. From 1944 to 1976, Robert and Gladys McFarlen True had their grocery store here, except for a short time when James and Susie Rodman Lewter had it. The building served as a post office annex in the early 1940s when the post office was next door.

The Madison Drug Company was established at 210 Main Street by Dr. Luther Wikle and his partner Ben Porter in 1912. Wikle later sold his interest to William Russell, a son of the constable of that name who also ran the gristmill for which Mill Road is named. In 1903, Constable Russell was killed by a woman when he served repossession papers at her house in regard to nonpayment for her furniture.

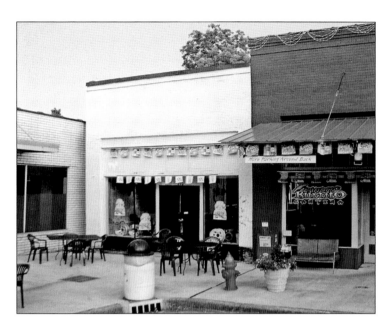

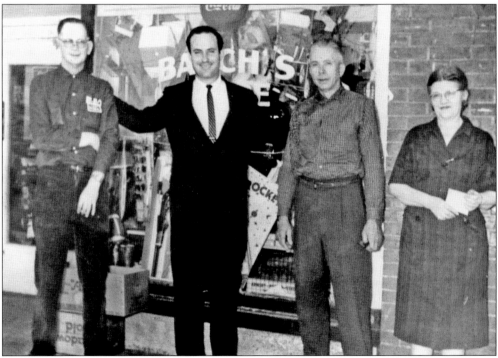

Joe Balch had a store at 212 Main Street for a number of years. He is on the left in this 1962 photograph with candidate for state governor Ryan DeGraffenreid (second from left). Doc Hughes and his wife, Sarah Parham, are at right. The Hughes drugstore was at 200 Main Street, but Hughes, a popular former mayor of the town, owned this building also.

YOUNG MEN!
PABST'S
OKAY SPECIFIC
CURES POSITIVELY AND WITHOUT FAIL
GONORRHŒA AND GLEET
NO MATTER HOW SERIOUS OR OF HOW LONG STANDING.
PABST'S OKAY SPECIFIC CURES
WHEN ALL OTHER MEDICINES HAVE FAILED.
No case is known where a cure has not been accomplished.
Gleet Cases of ten to fifteen years' standing can be cured with it.
It is an internal remedy and cannot produce stricture.
Contains nothing injurious to the constitution and can be taken without inconvenience or detention from business.

PRICE, $3.00.
FOR SALE BY
John M. Burton,
DRUGGIST.
MADISON, - - ALA.
And All First-class Drug Stores Everywhere.
MANUFACTURERS AND PROPRIETORS:
PABST CHEMICAL CO.

John Winston Burton established the first pharmacy in Madison in 1871 at the east end of Main Street, the site of the two-story Hughes Hardware building at 214–216 Main Street. John Mullins Burton operated the drugstore here by 1903, when he bought the business from his father, who died in 1904. In 1908, the business was moved to 200 Main Street. Pictured is a flyer from John Mullins Burton's store.

William Canterbury had a store at 214–216 Main for a time. Doc Hughes purchased the building, with apartments upstairs and a funeral parlor downstairs operated by James Ashford. Gene and Marion Hughes Anderson operated the site, including 212 Main Street, as a hardware store from 1946 to 1996 after Marion's father gave them the building. Their sons Walt and Larry are the current owners.

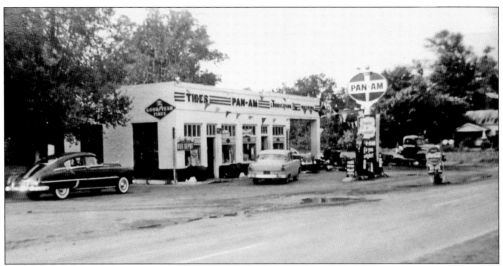

The Pan-Am service station and bus depot, owned by "L.B." Collier, is noted on this photograph as being "on the old route of Highway 20." The scene appears to be in the 1950s beside the railroad, as viewed from the Church and Front Street intersection. Today, that site is the location of the Glass Center and Animal Trax exotic pet store. Note the house at right, behind the railroad and 216 Main Street.

The Union records of the May 1864 surprise engagement at Madison (when a Confederate force attacked with four cannon and 1,000 cavalry troops) call it an "affair" rather than a battle. The battle was fought in a pouring rain, limiting casualties. The Confederates had come for the Union supplies, which they carried away. The marker is near the junction of Church and Front Streets.

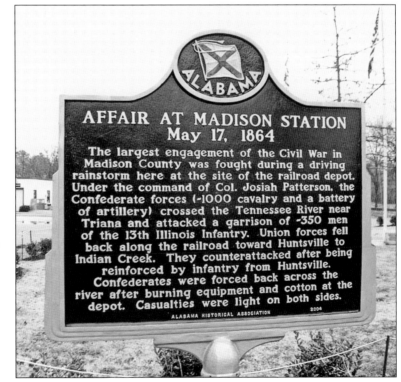

ALABAMA

AFFAIR AT MADISON STATION
May 17, 1864

The largest engagement of the Civil War in Madison County was fought during a driving rainstorm here at the site of the railroad depot. Under the command of Col. Josiah Patterson, the Confederate forces (~1000 cavalry and a battery of artillery) crossed the Tennessee River near Triana and attacked a garrison of ~350 men of the 13th Illinois Infantry. Union forces fell back along the railroad toward Huntsville to Indian Creek. They counterattacked after being reinforced by infantry from Huntsville. Confederates were forced back across the river after burning equipment and cotton at the depot. Casualties were light on both sides.

ALABAMA HISTORICAL ASSOCIATION 2004

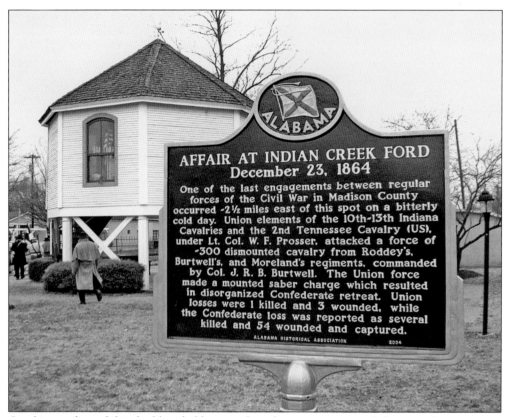

On the east face of this double-sided historical marker is a summary of the second engagement in Madison. This time, it involved a Union surprise attack at dawn on one of the coldest days in years. Indian Creek had frozen over, and the Union bugler's lips froze to his instrument. Uniformed enactors are shown retreating past the Roundhouse Replica Museum on the Village Green at Front Street.

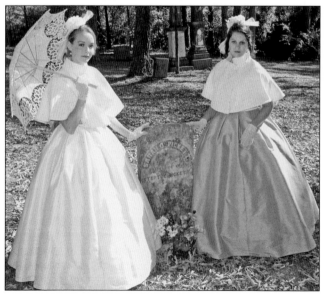

Here, a pair of Madison Belles (enactors Juliana Johnson, left, and Ramsey Griffin) is shown at the grave of Sarah Orrick Chilton Pickett, wife of Steptoe Pickett, in the Madison City Cemetery. Sarah's family suffered severely from the Civil War, going from the highest level of plantation life to near bankruptcy, which forced Sarah to move from their Triana plantation into Madison.

80

Steptoe and Sarah Pickett's 13th child, Anna Corbin, married Thomas Bibb Jr. He was a son of Alabama's second governor, Thomas Bibb Sr. Their daughter Felicia Pickett married Reuben Chapman (pictured). Reuben was governor of the state from 1847 to 1849. The Chapmans' son Steptoe Chapman died in the Civil War, their house in Huntsville was burned, and Reuben was imprisoned by the occupying Union troops.

Madison Belle Ramsey Griffin strolls past the Roundhouse Replica on the Village Green. The railroad's sign for Madison is displayed along the tracks at the site of the old depot, where the first local Civil War engagement was fought in May 1864. The Roundhouse structure has been the hallmark of Madison since 1898 and is believed to be unique in the nation.

The old icehouse on the Village Green beside the Roundhouse Replica was built in the 1920s by James Gormley, father of Alda Florence "Tiny" Gormley Sturdivant. He was depot agent at the time and constructed it for storage of garden produce to sell to train passengers. Later, it was used to store ice in the summer and coal in the winter for sale to Madison residents. The Village Gazebo is at right.

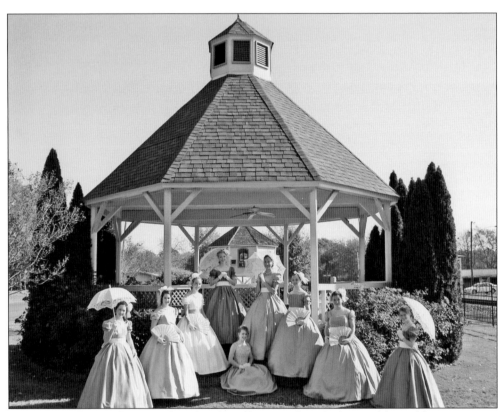

The 2012 Madison Belles are gathered at the Village Gazebo, which is used for weddings, concerts, and various activities during public events along the Village Green. Standing, from left to right, are Carley Beth Goode, Ramsey Griffin, Juliana Johnson, Alecia Eidsaune, Joylyn Bukovac, Cailyn Guthrie, Abbie McKee, Caroline Masterson; seated is Caroline's sister Raegan Masterson.

Four

HISTORIC HOMES, CHURCHES, AND SCHOOLS

A few of the historic homes of the Madison area are presented in chapter one to reflect upon the circumstances of later formation of the town and its culture. Chapter two includes the home of Madison mayor John Buchanan Floyd to illustrate postwar frugality at the time of building the first city hall. Chapter three connects the long-gone home of merchant George Washington Wise at Garner and Martin Streets to proximity with his store. His home was quite close to the store, across Martin Street and to the east only one block away on property that his father-in-law, George Washington Martin, purchased from James Clemens before the town lots were offered for sale. The history of the house at 16 Main Street is included in chapter three because the house was used for businesses and family residences.

Chapter four deals with more of the homes located in the original residential core of the town and with a few that were constructed outside the historical district but are within today's expanded limits of the city. The selected homes are presented with the premise that a house is more than architecture. Houses are a reflection of the people associated with them and keys to understanding the lives of their owners. The homes depicted here represent only a few of the extensively interconnected pioneer families who were citizens of the town, going to school and worshipping in the facilities also shown in this chapter. Unfortunately, several of the truly historic homes of old Madison have disappeared with the ages, but in some cases, photographs from long ago have been found and digitally copied. The same is true of the historic churches and schools. The structures that remain today have been typically updated through time, so their images in recent photographs may not always closely match their historical appearances. Still, they provide insight into the legacy of the families that built a town, which has, for over 150 years, survived wars, economic depressions, and epidemics to stand in modern times as one of the state's strongest and fastest-growing cities.

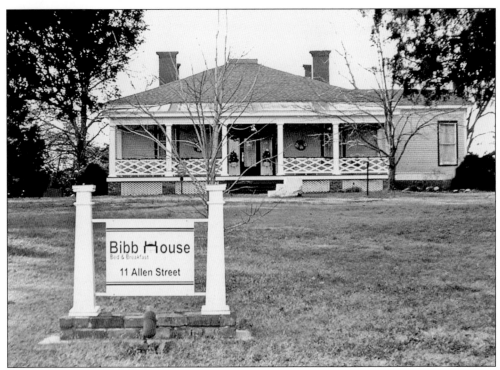

The Bibb House at 11 Allen Street is in the National Register of Historic Places. It was built in 1867 by James Henry Bibb, one of the merchants who petitioned to incorporate the town. Incorporation was approved in 1869. Bibb served on the first town council but died of measles the next year at age 44. His niece Mary Ann, a daughter of William Parham, was the mother of Madison merchant James Henry Cain.

The house at 12 Main Street was built in 1905 by Charles Strong (who served as mayor from 1903 to 1917) after a fire that destroyed his first house on this site of the old Doolittle blacksmith shop. Thomas and Sara Landman Whitworth purchased and remodeled the house in 1952. Here, Madison Belle enactors, from left to right, Ramsey Griffin, Juliana Johnson, Alecia Eidsaune, and Joylyn Bukovac take respite in its shade on the lawn.

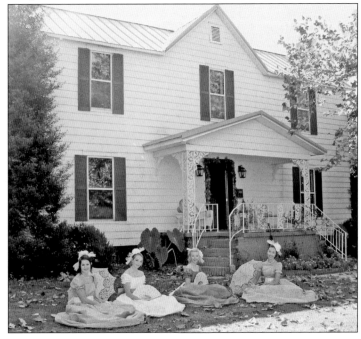

James Bailey was a squatter on Indian land. In the early 1800s, he built a two-story cabin as a stage stop and inn near County Line Road on Mill Road at a place called Bailey Springs at that time. That cabin is still intact, incorporated into the interior of the home of Charles Whitworth, a local veterinarian who lived at 12 Main Street. The cabin is probably the oldest such structure still standing in the region.

The Bailey cabin within the Charles Whitworth house is not visible from the road. James (1779–1843) and his wife, Sarah Johnston Bailey, are buried in a small family cemetery not far behind the house. Bailey descendants and associated family members, including Edmund J. Hughes, Rev. Reuben W. Crutcher, Jesse Abernathy, and several Word children, are buried here.

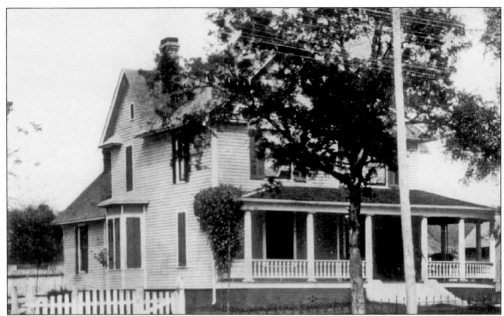

The house at 17 Front Street (at the junction with Sullivan Street) was built around 1904 by banker and merchant Matthew Harvey Anderson. He married Annie, daughter of Dr. John Hertzler. It was owned by Dr. James Allen Kyser from 1926 to 1976, but it was later abandoned for many years. In 1997, it was rebuilt by Anthony and Cindy Sensenberger, owners of 14 Main Street and the Main Street Café, before total collapse.

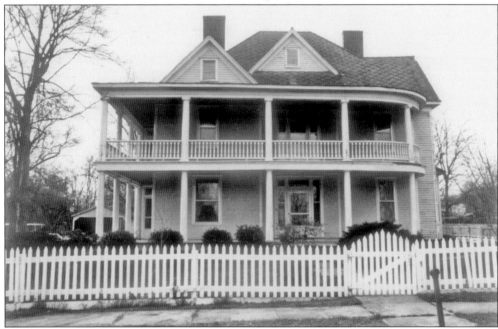

In 1904, James Edward Williams, a farmer and entrepreneur, bought the property at 19 Front Street and constructed this two-story house after moving back the smaller dwelling of physician and depot agent William Dunn. The Dunn home was raised, put on logs, and turned 90 degrees to face west, then attached behind the new structure. An old livery stable is now the separate garage.

James Edward Williams married Martha "Mattie" Susan Whitworth. Over many years, their house was a community center for social activities, including gatherings of various ladies clubs. That could be an underlying reason why James started a telephone company in Madison in 1919. Here, he and Mattie are shown inside their home at 19 Front Street.

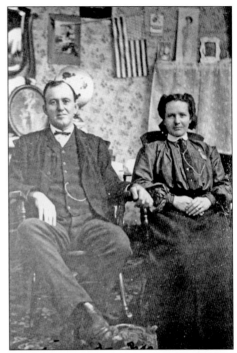

Tillman Williams Sr. is pictured at the store of his father Jim Williams on page 55 of this book. In 2004, Tillman Williams Jr. visited the home of his classmate and lifelong friend Percy Brooks Keel. Their memories were recorded for the oral history collection of the Madison Station Historical Preservation Society.

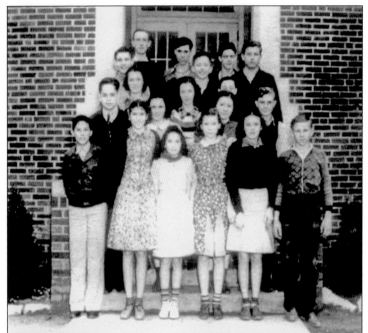

This 1939 school yearbook freshmen class photograph shows Allyne Whitworth (third from left, second row) and Tillman Williams Jr. (second person, fourth row), a grandson of James Williams. Allyne's grandfather was John David Whitworth, brother of Mattie Whitworth Williams. Allyne married Charles Chennault, son of Gen. Claire Lee Chennault of World War II "Flying Tigers" fame.

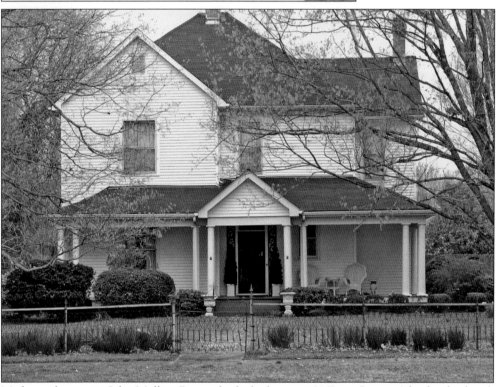

Madison pharmacist John Mullins Burton built the house at 21 Front Street. After her husband, Tom Logan Bradford, died, John's daughter Fannie also lived here with her daughters. Fannie was a reporter for the *Huntsville Times* newspaper. Carl Allen Williams, brother of Tillman Williams Jr., owned the house in the 1950s.

The wife of merchant William Benford Humphrey purchased 23 Front Street from Frank Hertzler, who bought it while living next door at 25 Front Street. Humphrey constructed the 1914 house, his lot including the old "Post Office Lot" and other parcels previously owned by Dr. Sullivan, Hezekiah Parham, James Elijah Bailey, two Fletchers, and others but never by Thomas J. Clay as town tradition claimed.

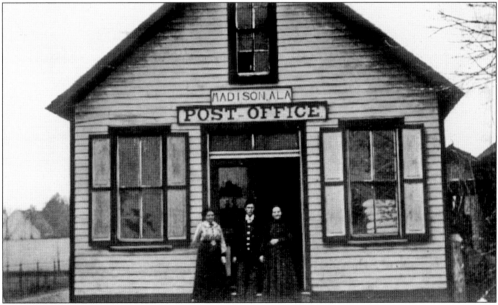

This post office building was located where Buttermilk Alley meets Front Street, on the "Post Office Lot" mentioned in several deed records. That was land initially owned by J.W. Cosby, the second postmaster of the town, in 1861. The people pictured are, from left to right, siblings Mary Alabama, William Thomas, and Kate or Sally Gewin. Their father, Christopher, was postmaster from 1875 to 1910. Mary was postmaster from 1911 to 1915.

This 1937 photograph shows Madison merchant William Benford Humphrey (1871–1944) on the left and his wife, Nancy Wade Parham (1874–1948), on the right. Nancy's brother was Hezekiah Parham, who lived on Sullivan Street. Nancy purchased the lot at 23 Front Street under the name Wade Humphrey on December 29, 1913. William was a son of James Alexander Humphrey and brother of Hermon.

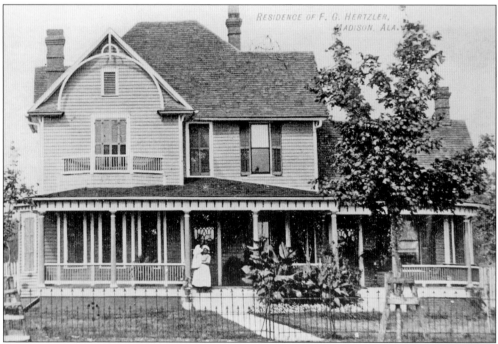

Frank Garber Hertzler, a son of Dr. John, built his 25 Front Street house around 1905. He had a Main Street store and a farm on today's Redstone Arsenal. Frank married in 1887 to Marietta Sullivan, who is pictured the front porch with their baby girl Jewell. Marietta's father, Dr. George Richard Sullivan, owned most of the next-door property at 23 Front Street from 1868 to 1891. The doctor was the namesake of Sullivan Street.

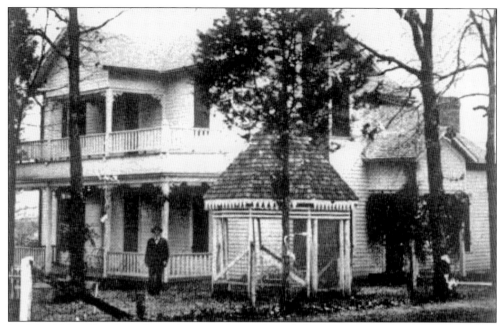

Dr. John Huber Hertzler is shown between the gazebo and the front porch of his home in Madison at the southwestern corner of College and Church Streets. He came with his wife, Annie Garber, and seven children from Pennsylvania by way of Ohio in 1869 to help the South rebuild after the Civil War. Hertzler had been a Union captain during the war.

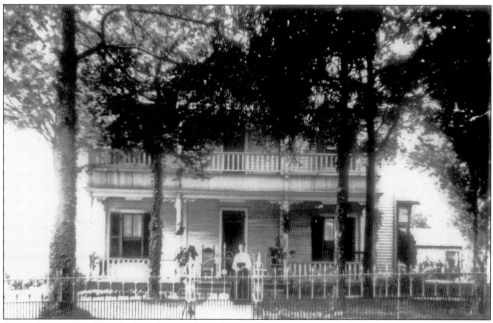

Here, Annie, Dr. Hertzler's wife, stands in front of her home. It is believed to have been the first house in Madison to have metal tanks installed to catch rainwater from gutters and store it above the first-floor level. This enabled the first use of indoor plumbing in the town, an idea that quickly was copied as a better method than hand pumping water from cisterns and carrying it inside.

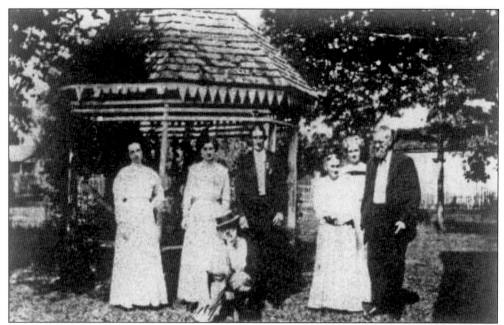

Gathered at the gazebo before 1916 are, from left to right, (standing) Mary Hertzler, Mary Bradford Lanier (wife of Shelby Lanier), Daniel Hertzler, Annie Hertzler, Annie Rachel Hertzler Anderson, and Dr. John Hertzler. Harvey Gordon Anderson, son of Matthew Harvey Anderson and grandson of Dr. Hertzler, kneels in front. Dr. Hertzler and his wife both died in 1916.

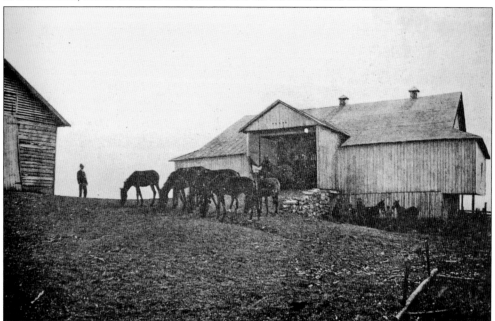

The large house and barn of Dr. John Hertzler, built about five miles southeast of Madison on land that is now part of Redstone Arsenal, are featured for their innovations in the *Huntsville and Madison County, Alabama* 1908 publication from the Business Men's League of Huntsville. The publication extols the barn's design, allowing hay to be taken into the barn on a ramp and then dropped down to be removed later from a lower level.

In 1905, Madison merchant James Henry Cain, son of Thomas Jefferson Cain and brother of Robert Parham Cain, bought the 18 Arnett Street property, which was constructed around 1880, for his wife, Charlotte Slaughter, daughter of Dr. John Robert and Mary Lanford Slaughter, namesakes of Slaughter Road. In 1936, James divorced Charlotte and, in 1937, married Woodie Latham, widow of Joseph Eugene Collier.

While James Cain provided for Charlotte after their 1937 divorce, he had previously provided for their son John by building this house at 15 Arnett Street in 1931. John and his wife, Lucille Wade, did not occupy the house until 1938 to 1949. Roy Stone, chairman of the county commission and for whom Stone Middle School in Huntsville was named, lived there initially.

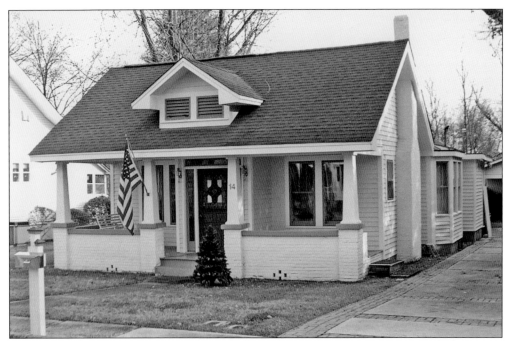

Before he died in 1938, James Cain also built this house at 14 Arnett Street in 1927 for his son. It was the honeymoon cottage for John and Lucille Wade Cain. They lived in it until James died. The house illustrates one of the typical characteristics of homes in the area: a small front face but deep structure back from the street, a design that was dictated by lot dimensions from the old days.

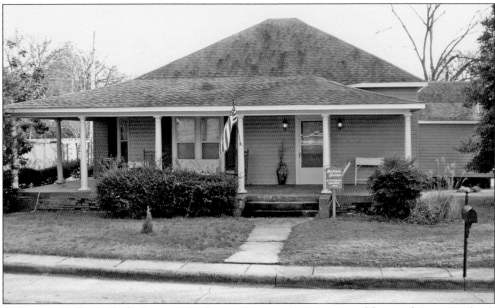

William L. Hafley built the house at 20 Arnett Street in 1910. It is a prefabricated Sears, Roebuck & Co. kit house, one of two in the historic district. This house was subsequently owned by Charles Ford Apperson Sr. and his wife, Kathleen, daughter of John Longstreet Humphrey. It later was inherited by Kathleen "Naneen" Apperson, who married Doward Williams.

Charles Ford Apperson Sr. was a Madison city council member from 1936 to 1940 and mayor from 1950 to 1957. He was the father of Betty, Charles Jr., Dora Cain (who married her schoolmate Marcus Tuck), Kathleen, and James Apperson. Charles Apperson Jr. (1923–2007) built a large house in the southwestern corner of the junction of Sullivan Street with Brown's Ferry Road late in his life.

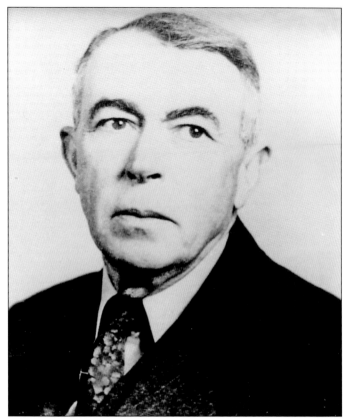

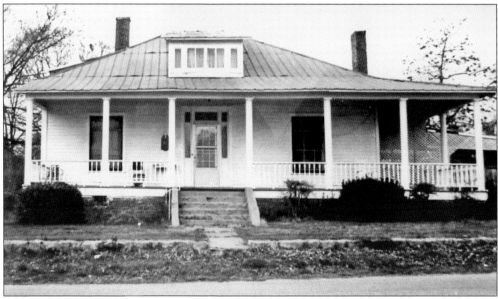

Built by farmer Roy W. Thorson in 1912, the house at 113 Maple Street was purchased in 1980 by Joan Lynch Spruiell. Joan married Scott Haas in 1984. She is a descendant of the Lynch family that farmed the land around the Fowlkes Cemetery on Capshaw Road west of Jeff Road. Scott is a son of Madison County historian Dorothy Scott Johnson by her first husband, William Haas.

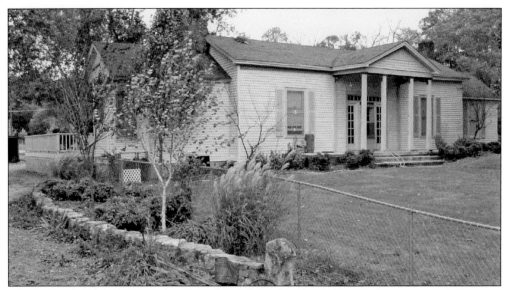

The Lanier house at 154 Maple Street faced the railroad. The house dates from at least 1884, according to death certificate details of John Ford Lanier's wife, Ada Johnson, originally of Natchez, Mississippi. The Lanier family settled on arsenal land in the 1820s. Brothers Burwell Clinton and Isaac Alexander Lanier moved to Madison after the Civil War. John Ford Lanier, a deputy sheriff, was shot and killed in 1900.

The Lanier house complex, as viewed here from Maple Street, includes a pond from which locomotives were resupplied with water. David Shelby Lanier, born 1887, was a son of John Ford Lanier and mayor of Madison from 1940 to 1944. His son John Logan Lanier lived across the tracks from this complex. The family is ancestrally connected to that of George Washington, first president of the United States.

The house at 116 Martin Street was built in the 1880s for Berry Leeman Martin, son of George Washington Martin and Nancy Leeman. Berry was the depot agent in 1891 when his mother was killed there by a train. The house was bought in 1920 by Joel Brewer, and three generations of that family lived in it, including Alice Brewer and her brother Joe Brewer, a genealogist of the family.

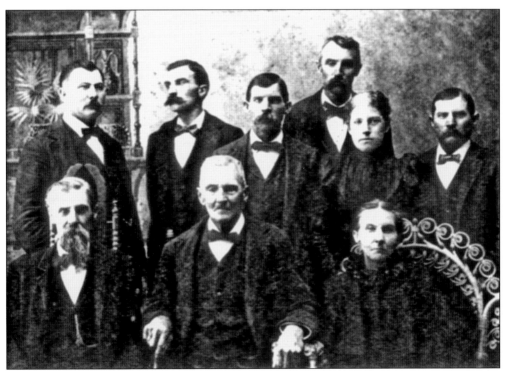

Joel Brewer was mayor from 1923 to 1927. He married Katie Ashford Watkins, daughter of James Albert Watkins and his second wife, Martha Martin, a daughter of George Washington Martin. Joel's daughter Alice married Henry Hilson, and their son Brian Hilson became president of the Huntsville–Madison County Chamber of Commerce. Joel's grandfather John N. Brewer is at front and center.

The cotton gin owned and operated by Joel Lee Brewer still stands—but just barely—behind the Glass Center and the Animal Trax shop, east of the southern end of Church Street and on the north side of the railroad tracks. When Charles Apperson Sr. dictated his memoirs in 1977 at age 88, he stated that there was a Dame (family name) school on Maple Street, just north of the gin.

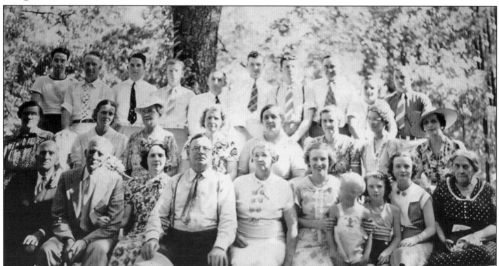

Pictured is a 1937 reunion on Monte Sano Mountain in Huntsville of Brewer, Watkins, Martin, and Wise family members interconnected in Madison. This image, from the collection of Joe Brewer (son of Joel), has no identifications, but it appears that the man with eyeglasses at front and center is Joel Brewer, 10 years after being mayor. The woman to his right may be Katie Watkins Brewer.

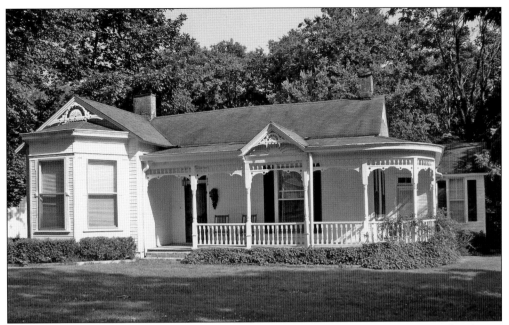

The house at 310 Martin Street dates from the early 1900s. Elijah Thomas Martin, brother of George Washington Martin, was likely its builder. Elijah's daughter Lena lived here with her husband, Robert Parham Cain, who owned the store at 110 Main Street where George Martin became Madison's first merchant. Later, John Logan Lanier lived here. George's son Jordan married Helen Lanier in 1886.

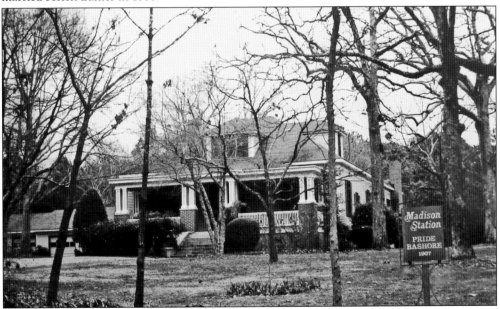

Dr. William Thomas Pride built his home at 320 Martin Street in 1911. The doctor's nephew James Harvey Pride (born 1877) married Sally Betts, sister of Edward Betts, the man who set up the Nuremberg Trials after World War II. Edward was a great-grandson of Charles Edward Betts, the first settler in the heart of Madison's current boundaries. William's great-grandmother was Eleanor Wardrobe Gray, a woman of Scottish nobility who lived in Madison before 1818.

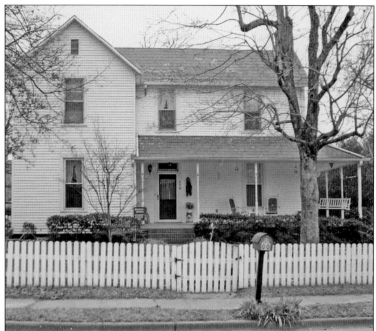

William E. Canterbury, born in 1865, married Matilda Binford in December 1904. A few weeks later, in 1905, he bought this property at 110 Church Street from Frank Garber Hertzler and Matthew Harvey Anderson. For a time, William had a store at 216 Main Street, the future location of Hughes Hardware. Henry Keebler owns the house now.

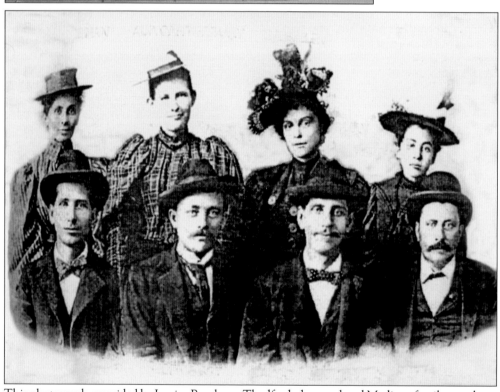

This photograph, provided by Louise Brockway Thedford, shows related Madison family members. Pictured, from left to right, are (first row) Henry Canterbury, Morton Best (born 1869), Balden Canterbury, and Simon Rodman (born 1854); (second row) Nannie Rodman (born 1857, née Nale, wife of Simon), Ada Canterbury, Ida Bailey, and Annie Rodman.

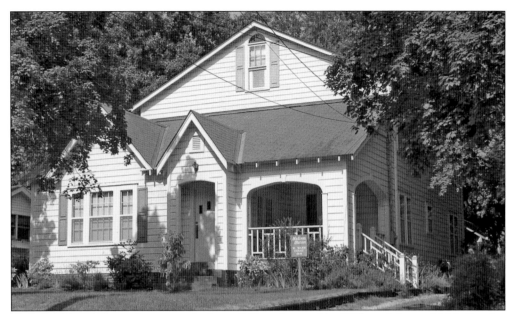

The 112 Church Street home was built in 1935 and owned by William John and Vida Barclay Wann. They had two stores on Main Street; one was the former store of William's brother-in-law Dea Thomas after Dea's death. William and Fred Wann were brothers from Woodville, Alabama. William's son William Barclay Wann married Sarah Farley and lived at 225 Mill Road. Fred lived at 302 Church Street.

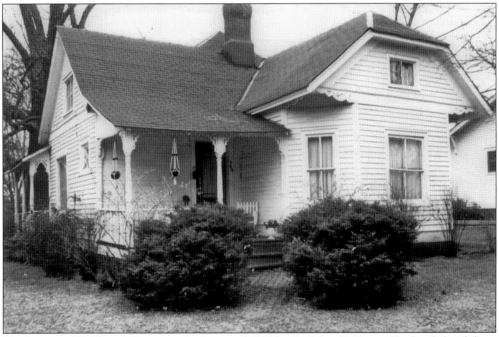

The home at 203 Church Street was built around 1885 by Dr. Julius T. Haney. His family lived there until 1903, after which, several others owned the house into the 1930s. By 1940, William C. and Laura Jane Gillespie purchased the house. William, son of Milton P. Gillespie, was superintendent of the Madison Water Works for many years. Laura taught school in the Madison system.

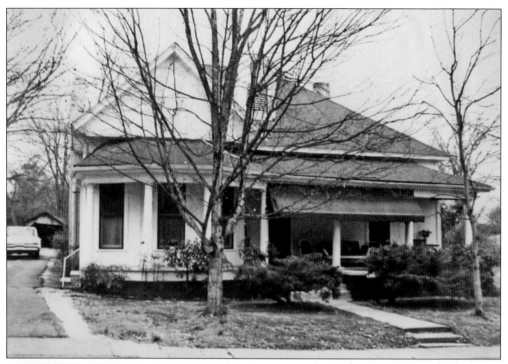

Around 1910, Joe Pruitt built the house that stood at 204 Church Street until 2005 when it burned. In 1940, Pruitt was living in Huntsville, operating a secondhand furniture store. Howard Dublin bought the home in 1937 and rented it to others while he lived in Greenbrier. He lived in his Madison home from 1942 until his death in 1972. His widow Sally (née Williams) lived in it until she died in 1994.

Howard Dublin was mayor of Madison in 1949 and 1950. In 1910, he and his brother Clyde were living with his grandmother Mildred Bowers Whitworth and, in 1900, with their uncle James Williams (who married Mattie Whitworth). Howard and Clyde were great-grandsons of James Dublin, who married Eleanor, daughter of Roland Gooch (1778–1850), a son of James Gooch of Virginia.

Thomas Riddle was principal of Madison school, a farmer, director of Madison's bank, partner in a buggy and harness dealership, and an entrepreneur with a horseless carriage promoting his real estate development business. He built the 301 Church Street house in 1910. By 1926, both Thomas and his son Harry left Madison for the Birmingham area, where they were involved in investment businesses.

Arthur Holding Lewis bought the property at 302 Church Street in 1874. Arthur was a son of Triana's Meriwether Lewis, owner of a plantation and steamboats. Arthur had a store at the location later housing James E. Williams at Wise and Main Streets. Arthur married Mattie Cartwright in 1873 and became an ancestor of Humphrey, Hughes, Spencer, and many other families of Madison.

Cora Mae Lewis Humphrey (1879–1960) was raised in the house at 302 Church Street, which is now in the National Register of Historic Places. This picture of Cora was taken around 1925, the year that her husband, James Hermon (some family members spelled it as "Herman") Humphrey died. Cora Mae became an astute business person herself, owning a good bit of property.

James Hermon Humphrey (1869–1925) built 206 Church Street in 1898 when he married Cora Mae Lewis. Humphrey family members here are reported to be (sitting on steps) James Alexander (father of Hermon) and James Hermon at far right. The woman standing is likely Etta Abernathy Lewis with baby Mattie Belle, sitting next is Cora, and the next woman is Posey Burwell, wife of James Alexander. Others are unidentified.

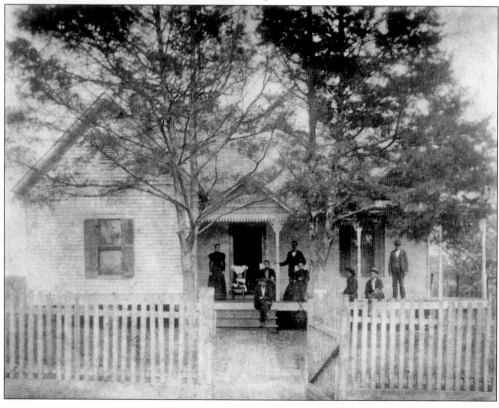

In 1922, Thomas G. Riddle built the house next door to his own for his son Harry. In 1926, when the Riddles left Madison, the property at 303 Church Street became the home of Madison pharmacist Doc Hughes, who also served as mayor from 1944 to 1949. Harry worked in the Bank of Madison. The house has been the Carl Sampieri home in recent years.

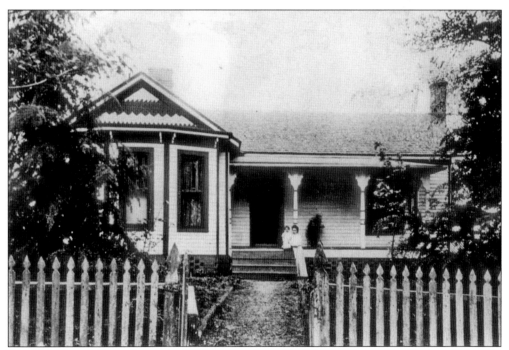

The 306 Church Street house in 1906 was purchased by Thomas Logan Bradford and his wife, Fannie East Burton, a daughter of John Mullins Burton. Here, Fannie holds her younger daughter Emma. Tom committed suicide in the home by overdosing on morphine from his drugstore in 1918 at age 35. A note he left cited poor health and bad business issues. Fannie moved to her father's house after Tom's death.

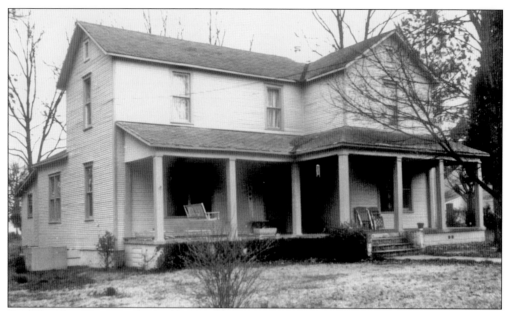

Dea Theodore Thomas, who had his store at 206 Main Street beside the bank, lived at 307 Church Street. Dea's wife was Nora, daughter of Andrew Wann of Woodville, Alabama. Dea's brother-in-law, William Wann, had a store at 202 Main Street, the other side of the bank building from Thomas's store. When Dea died in December 1917, William also operated the store at 206 Main Street before he passed in April 1922.

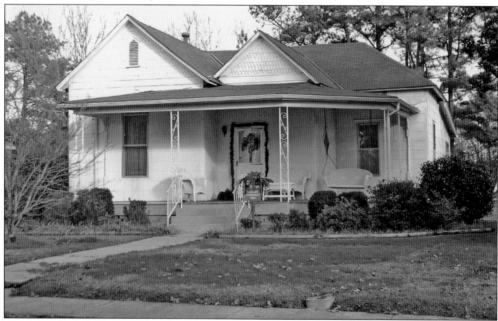

The residence at 308 Church Street is a Sears, Roebuck & Co. kit house assembled by Wesley Taylor of Mobile in 1910. He sold it in November that same year to J. Pryor Farley. The home passed to W.C. Gatlin. He then sold it in 1943 to Claude Sturdivant, who married Alda Florence "Tiny" Gormley. Claude was a son of blacksmith Robert Lee Sturdivant, who was mayor from 1929 to 1931 and 1934 to 1940.

Not only was Robert Sturdivant a mayor of Madison, he was also listed at age 25 in Mooresville as a merchant in business with his brother Thomas. Another brother, Walter, was listed in Robert's household as a cattle dealer. Robert had married Bettie E. Hank on September 28, 1899, in Jackson County. They had no children in their household in Mooresville, according to the June 1900 census.

James C. Gormley (1883–1948) was the father of Tiny Sturdivant (née Gormley) of 308 Church Street. James and his wife, Ora, lived on the site of Dr. John Hertzler's house at College and Church Streets until 1939, when it was purchased by Dr. John's daughter Annie Hertzler Anderson. James was depot agent, city clerk, and water department head responsible for getting a water system throughout Madison in 1936.

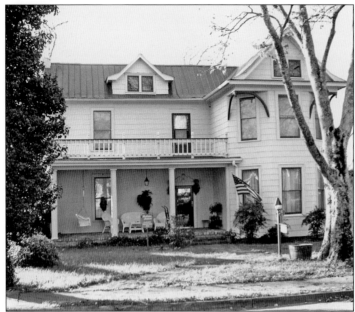

Michael Farley was one of the earliest landowners in the area just east of Madison. He died in January 1832 and is buried on his land in the Farley-Crutcher Cemetery south of Old Madison Pike. In 1892, Michael's grandson Joseph Bruce Farley married Nancy Hesseltine "Miss Hessie" Gillespie, a schoolteacher. She built this house in 1911 at 313 Church Street after Bruce died of malaria in 1894. She never remarried and died on January 1, 1939.

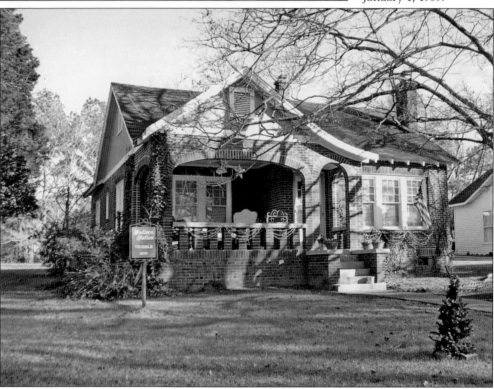

Caudis Henry Tribble graduated from Madison school in 1919. He and Ozelle Hereford married in 1924 and lived at 316 Church Street. His parents were William H. (1876–1945) and Annie Inez (1879–1928) Tribble, both buried in the Madison City Cemetery's old section. According to the 1920 census, the William Tribble family lived near Samuel Palmer in the area of Palmer Road at County Line Road.

Robert Edgar "Pud" True and his wife, Gladys Naomi McFarlen, built the house at 318 Church Street, moving into it on January 1, 1942. They had been given the lot by Caudis and Ozelle Tribble for the reason of gaining good neighbors, but the Trues paid them for the lot within a year. At the time, this location was considered in the county but outside the boundaries of the town of Madison.

Gladys Naomi McFarlen was born in 1913 in Trenton, Jackson County, but she stayed with relatives to attend Madison County High School in Gurley for her high school years. In December 1931, Gladys secretly married Robert True in Gurley. He had come home from the Army on a three-day leave, and they decided then to marry, without Army permission. Here, they celebrate their 50th anniversary.

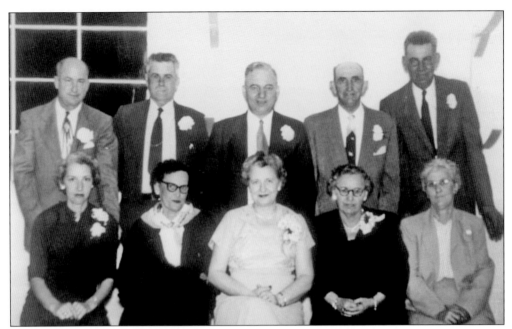

Town officials celebrate the completion of Madison's third city hall at 101 Main Street with their wives in 1955. Pictured, from left to right, are council secretary Robert True with wife, Gladys; police chief A. V. Kay with wife, Elizabeth; Councilman Caudis Tribble with wife, Ozelle; former mayor Howard Dublin with wife, Sally Williams Dublin; and builder of the facility Readus Riddle with wife, Ora Whitworth Riddle.

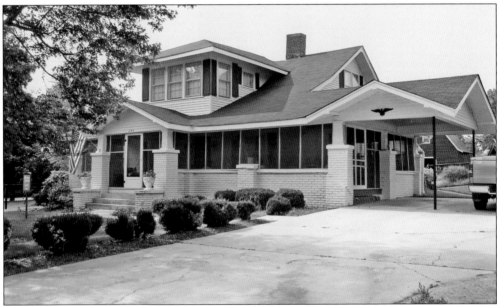

The home of Jack and Lillian Clift is at 243 Mill Road. They are longtime benefactors of the community in an impressive variety of ways. Jack is a son of Thomas W. Clift and Lessie Balch and a grandson of John T. Clift and Sallie Carter. John T. was a Madison county commissioner from 1909 to 1917 when the third courthouse was built in Huntsville. His name is on a west balcony wall plaque there.

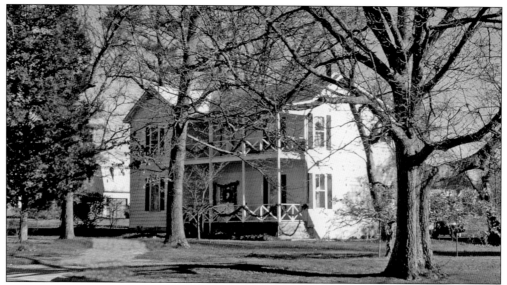

The property at 261 Hughes Road has been owned by Benjamin Bledsoe, Daniel Whitworth, and John Longstreet Humphrey, as well as the Collier and Drake families. Humphrey (1866–1920) married Elizabeth Bibb Cain. He was a son of James H. Humphrey (1818–1888) and Mary Douglass, and his grandfather was David Humphrey. Their Humphrey family lines connect into the Sneed, Darwin, and Strong families of Madison.

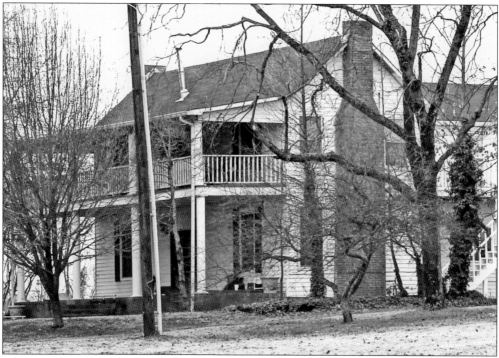

John A. Hughes built this farmhouse and apartment building at 1464 Hughes Road. He was a son of Edmund James Hughes, first educator of a school here before Madison was established. John married Laura Vaughn in 1901 and had Doc Hughes. John's brother Robert married Nannie Vaughn and was father of Gordon Pelham Hughes and Howard Hughes of Madison.

This south entrance view of the John Hughes house shows its depth. In 1910, John deeded land for Forest Hill School adjacent to Berea Church of Christ, near the junction of Hughes Road and Highway 72. The school closed after only nine years, and the land was sold back to John. The Berea Church is shown on page 119. The church was on land deeded by John's father, Edmund James Hughes.

The house at 104 Metaire Lane was relocated. It was constructed around 1818 on arsenal land by James Cooper for his bride, Charity Allison. James committed suicide in 1834. Later, Charity married Houston Lea. The house passed to the Fennell, Scruggs, and Harris families before Tyler and Evelyn Darwin moved the structure to Madison in order to rescue it from the Army surplus system in 1977.

Samuel Palmer came to Madison in 1870 at the invitation of his brother Osiah, who had settled in town after the Civil War and built a two-story house at Palmer and County Line Roads. Osiah went back to Ohio after his infant son Charley died. Palmer family records include the "Palmer Place" that became Gen. Robert E. Lee's home and, later, Arlington National Cemetery outside Washington, DC.

Osiah Palmer's 1870 letter to Samuel tells of Charley's death and extols advantages of life in Madison. The numbers and types of stores are discussed, as are the details of the house that Osiah had built. Even the local price of coal is something mentioned as being a great bargain, as many of the town structures were heated with coal brought by trains rather than by the cutting and burning wood. The photograph shows the letterhead and return address on envelopes of Samuel Palmer's business stationery.

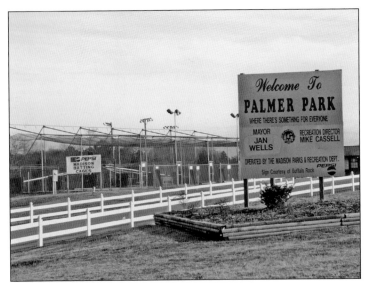

Osiah's letter to Samuel Palmer also tells of various native fruit trees in the Madison area. That may have influenced Samuel to relocate to town and become a nurseryman. His business stationery of the period reflects that he was a "grower of grape vines." Other records show that he grew fruit trees. Today, there are still fruit trees growing on the west side of the city's Palmer Park, near Samuel's house.

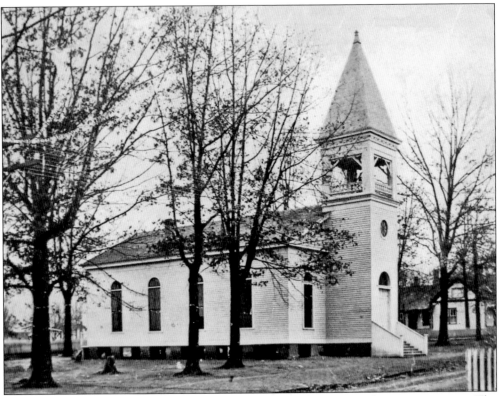

The Madison United Methodist Church at 127 Church Street gave the street its name. The church, organized in 1828, was initially located in the northeast corner of the junction of Hughes Road and Old Madison Pike. In an 1857 petition by James Clemens to the county commissioners regarding the roads, it is called Gooches' Meeting House. Roland Gooch deeded land for it there in 1837.

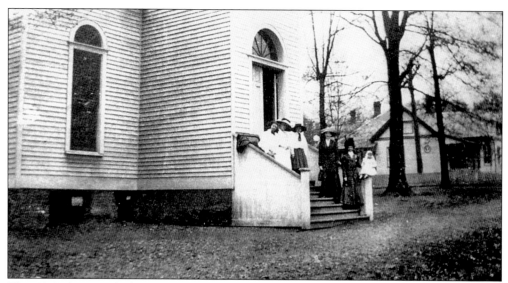

This 1910 photograph shows three unidentified girls of Madison plus two ladies from Gurley—23-year-old Reion Allison, wearing a dark dress and large hat, and Ethel Gaston with her baby Lucille, from the family of clergyman William Gaston. Reion lived in Gurley next door to Samuel True, father of later Madison resident Robert True, who was a cousin of Percy Brooks Keel through their respective Styles mothers.

Mattie Belle Lewis, wife of Gordon Pelham Hughes and daughter of Etta Abernathy Lewis, is shown at the organ, which she played for 63 years in the Methodist church. The auditorium of this building was pulled on logs by mules from the Hughes Road and Old Madison Pike intersection to its current location in 1873. The lot was purchased from Dr. Isaac Deloney, and it held a blacksmith shop.

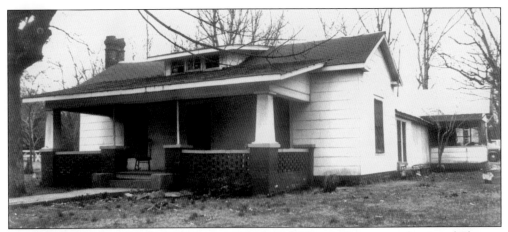

The parking lot of the Methodist church at Maple and Church Streets was the site of Thomas Wesley Carter's house at 202 Church Street. Carter (1872–1945) married Anna Spragins Farley. Carter's documented ancestry goes back to Rollo, the first duke of Normandy in 912 AD. The Carters arrived in Madison County in 1825 and connect to the Whitworth, Trotman, Crutcher, Clift, and Betts families.

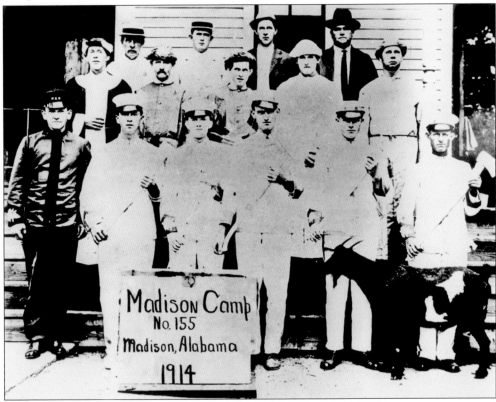

This group is reportedly gathered at the Methodist church, but some say this image was captured at the school. Pictured, from left to right, are (first row) Steven Gates, unidentified, Russell Balch, Hopkins Tribble, Emmett Landers, and John Landers; (second row) Joe Trotman, Archie Whitworth, Ben Porter, John Whitworth, and Ed Farley; (third row) George Sadler, Joseph Balch Sr., Theo Morris, and William Tribble (father of Caudis).

The Centennial Belles gathered in the Methodist church during celebration of the 100th anniversary of incorporation of the town with the name Madison rather than Madison Station. The official celebration lasted for seven days, from October 16 through October 22, 1969. Ladies in the town needed an official Centennial Belle button to publicly wear lipstick, rouge, eye shadow, and such during the celebration.

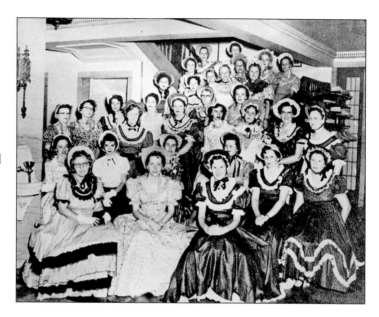

The Asbury Methodist Church, located at Gillespie and Hughes Roads, is now probably the largest church in Madison. It started as many churches do, with a split from the original Methodist church in town on Church Street. Oddly enough, it moved just about half a mile or so beyond the original site of its mother church, but on the opposite side of Hughes Road from where the original Methodist church had been.

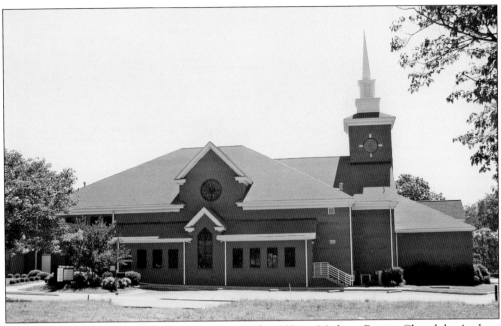

The First Baptist Church in Madison was organized in 1884 as Madison Baptist Church by Andrew Jackson Hardin and others. Hardin was ordained to the ministry in Lawrence County in 1866 at the request of Mount Zion Church. He was born in Kentucky in 1820, married Mary Freeman in Madison in 1859, and died in 1899. One of his children married a Douthit and another married a Peete of the local families.

The Church of Christ on Maple Street was organized in 1879. Its building was erected in 1881, was used for about 100 years, and stands behind the A-frame structure that is now the Cornerstone Word of Life at 132 Maple Street. The church property encompassed 3.5 acres of land. The original church merged with the one at Slaughter and Schrimsher Roads to become the one now at 556 Hughes Road.

The Berea Church of Christ was formed in 1898 by members of the Edmund Hughes family. After holding meetings in a brush arbor, Hughes deeded land in 1899 on the south side of Highway 72 and east of Hughes Road. Members of the Hughes, Carter, and Martin families cut logs from Rainbow Mountain to erect the building. The structure was used well into the 20th century, but it is now gone.

The Big Shiloh Primitive Baptist Church was founded in 1876. The building is on land purchased from Henry and Sally Clay in 1878. It is located near the north end of Maple Street, immediately south of the old section of the Madison City Cemetery. Meetings were held under brush arbors until a building could be erected. William Fletcher was the first pastor of the church.

Located at Perry Street and Stone Street in Madison's Pension Row district west of Sullivan Street, St. Elizabeth Cumberland Presbyterian Church was established in 1910. In 1870, another Cumberland Presbyterian Church bought rights to meet in the lower part of two-story Masonic Lodge 329 in the same area until the congregation could be ready to meet on its Lot 25 location across Sullivan Street per Deed Book OO.

The St. Peter United Methodist Church on Stewart Street was founded in 1887. Its location is likely the old site of Masonic Lodge 329. The Methodist trustees in 1899 were W.D. Bryon, William Collier, G. L. Love, R.M. Love, Sallie Mastin, Martin McCaulley, and James T. Toney. The current pastor is Danny Jefferson.

Madison Belle enactor Joylyn Bukovac pays respect to John T. Lipscomb. Lipscomb taught at the school founded by Edmund Hughes located south of Madison until the building was moved into the town after the Civil War. He thus became Madison's first public schoolteacher. His wife was Orrie Cartwright, daughter of Hezekiah and granddaughter of John Cartwright, pioneers of the area.

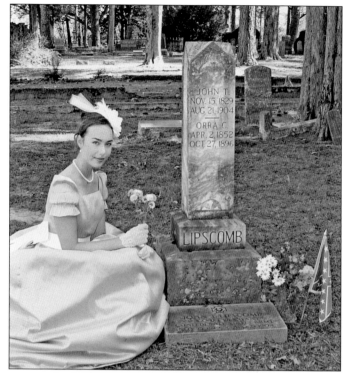

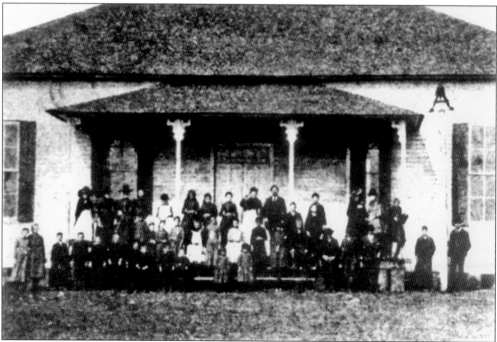

Madison Male and Female Academy was incorporated August 1885. This photograph was taken in autumn 1887. This school was closed by trustee John Buchanan Floyd around 1894. Floyd owned the building, and there was an argument over allowing one of his daughters to teach. Students then met in lawyer James Henry Strode's office until 1895.

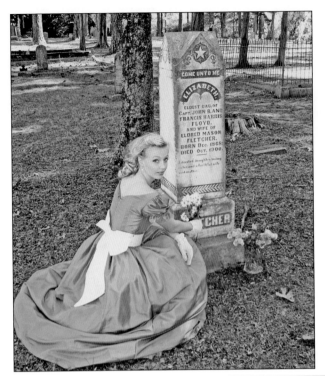

Madison Belle enactor Alecia Eidsaune decorates the grave of Elizabeth Floyd Fletcher. It is believed that John Floyd's daughter Ellen, though it could have been Annie or Florence, was not allowed to teach in Madison Male and Female Academy due to her "young age" in 1894, but none of his other daughters are known to be buried here.

This eight-page brochure for the 1895 September term proclaims the virtues of Madison High School, which included only grades one through eight. The brochure lists students of the term that ended in May, including 79 of the children of Madison residents of the time. The material also relates the various subjects being offered and the school's teachers, including 25-year-old Annie Floyd.

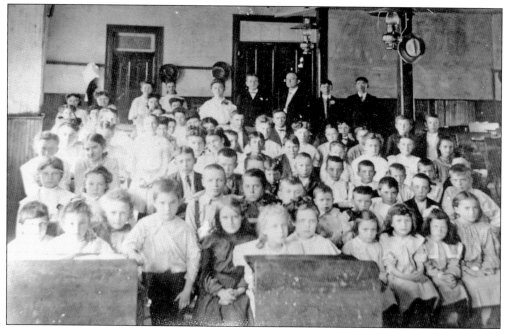

This photograph, labeled as being taken in 1905, shows the students in Madison High School when it was located near the south end of Church Street where the North Alabama Gas District office is today. The name of the school apparently was interchanged between Madison Training School and Madison High School. The adult staff stands behind the students.

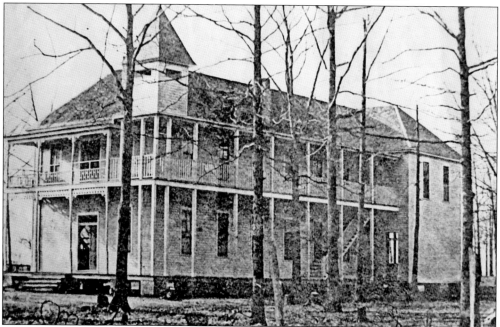

A 1924 photograph shows Madison Training School at College Street, where the Madison Elementary School of today is located. The school was rolled on logs pulled by mules up the slope from the southern end of Church Street in 1908, according to some now-deceased residents who witnessed the move. The structure was significantly modified after emplacement on the site.

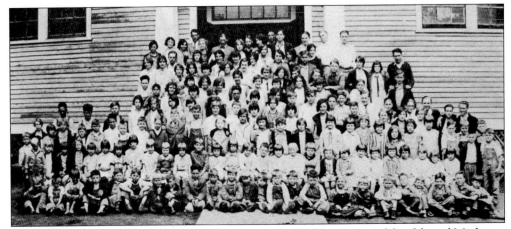

This photograph appears without a caption in the 1969 centennial booklet of Madison, commemorating the change of name of the town from Madison Station to just Madison. It appears to be of the entire student body and some staff of the Madison Training School, precursor to Madison Elementary School on College Street, situated west of Church Street and south of Mill Road, around the early 1930s.

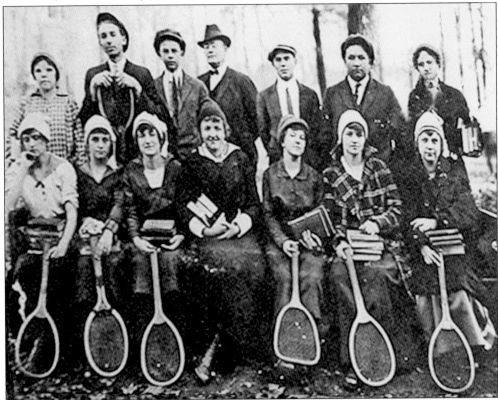

Here is the 1915 tennis team of Madison Training School, consisting of about a dozen players. The man in the center of the second row with a hat and bow tie is principal Thomas Riddle, the only male on the staff. All the others are unidentified, but they illustrate the attention given in the early 1900s to school sports. Madison Training School emphasized six-man football and outdoor-court basketball in the 1930s and 1940s.

This 1922 image of a school bus illustrates typical transportation provided to students. Julius Walter Bishop drove a bus from Binford Hill School into Madison. Note the flap over the engine. Students rode on plank benches with canvas side flaps to protect them from the wind and rain. They were called flaps because they did, indeed, flap in the wind. Note also that there are no windshield wipers.

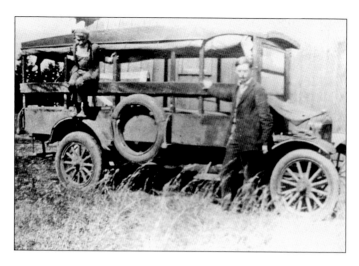

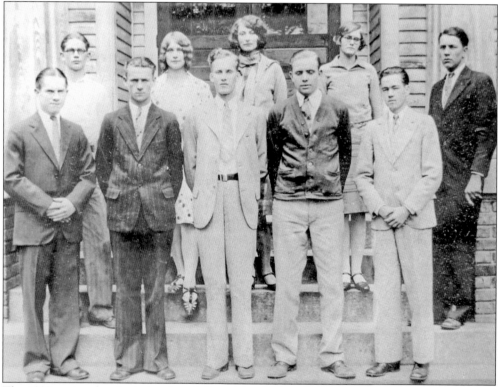

The 1929 senior class includes, from left to right, (first row) Bill Wann, Claude Sturdivant, Ira Balch, Yancy Hughes, and Charles Gormley; (second row) Joseph Balch, Kate Atkinson, Sarah Bedwell, Estelle Parton, and Ellis Brazelton. In the 1930s, this school's district extended from Jordan Lane in Huntsville to the county line on the west and from the Tennessee River north to the state line.

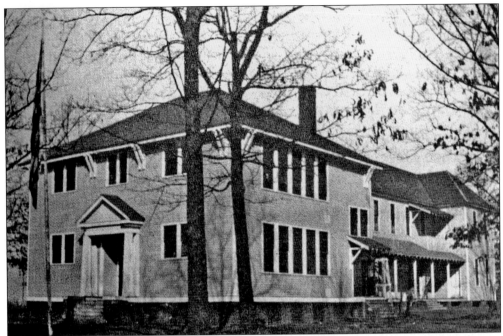

This photograph of the south entrance of the Madison Training School in the 1930s shows that the porches and balconies deteriorated to the point of removal, leading to renovation of the overall structure. Even the corner tower had been removed. The entire structure was replaced with a brick building in 1936. Most of the salvaged lumber was used to construct the second city hall on Martin Street at Garner Street.

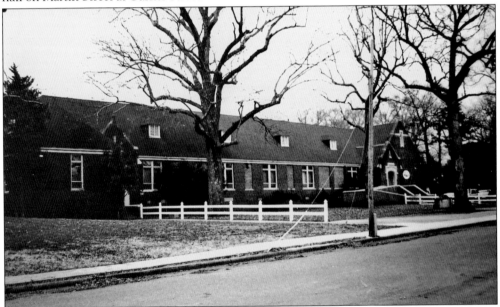

It was in 1934, the Great Depression era, that Madison successfully obtained government funds to construct a new school building on the Madison Training School site. This one was made of brick, with modern conveniences such as indoor toilet facilities and drinking fountains. It was completed and put into use in 1936, when the old structure was taken down.

This 1950 yearbook image shows lunchroom workers identified as Mrs. Woodie Latham Cain (left) and Lizzie Drake. On this page, the seniors state their gratitude toward all who "helped to bring us such a nice lunchroom." Prior to then, individual lunches were brought from home in sacks or pails. In 1939, Sarah Parham Hughes began offering lunches to needy students from a trailer in her backyard.

Cornelia Seay, widow of Henry, a black blacksmith born in 1855, donated land in the Pension Row area for a school to serve black children in 1936. After that school burned in 1947, West Madison Elementary School was built by 1953 on Wall Triana Highway, four miles north of the railroad, to serve the need and launch Madison into the modern era of education for all children.

Discover Thousands of Local History Books
Featuring Millions of Vintage Images

Arcadia Publishing, the leading local history publisher in the United States, is committed to making history accessible and meaningful through publishing books that celebrate and preserve the heritage of America's people and places.

Find more books like this at
www.arcadiapublishing.com

Search for your hometown history, your old stomping grounds, and even your favorite sports team.

Consistent with our mission to preserve history on a local level, this book was printed in South Carolina on American-made paper and manufactured entirely in the United States. Products carrying the accredited Forest Stewardship Council (FSC) label are printed on 100 percent FSC-certified paper.

MADE IN THE